Bird Mandalas Adult Coloring Book Vol 4

60 Entertaining Stress Relieving Bird Patterns

By Omar Johnson

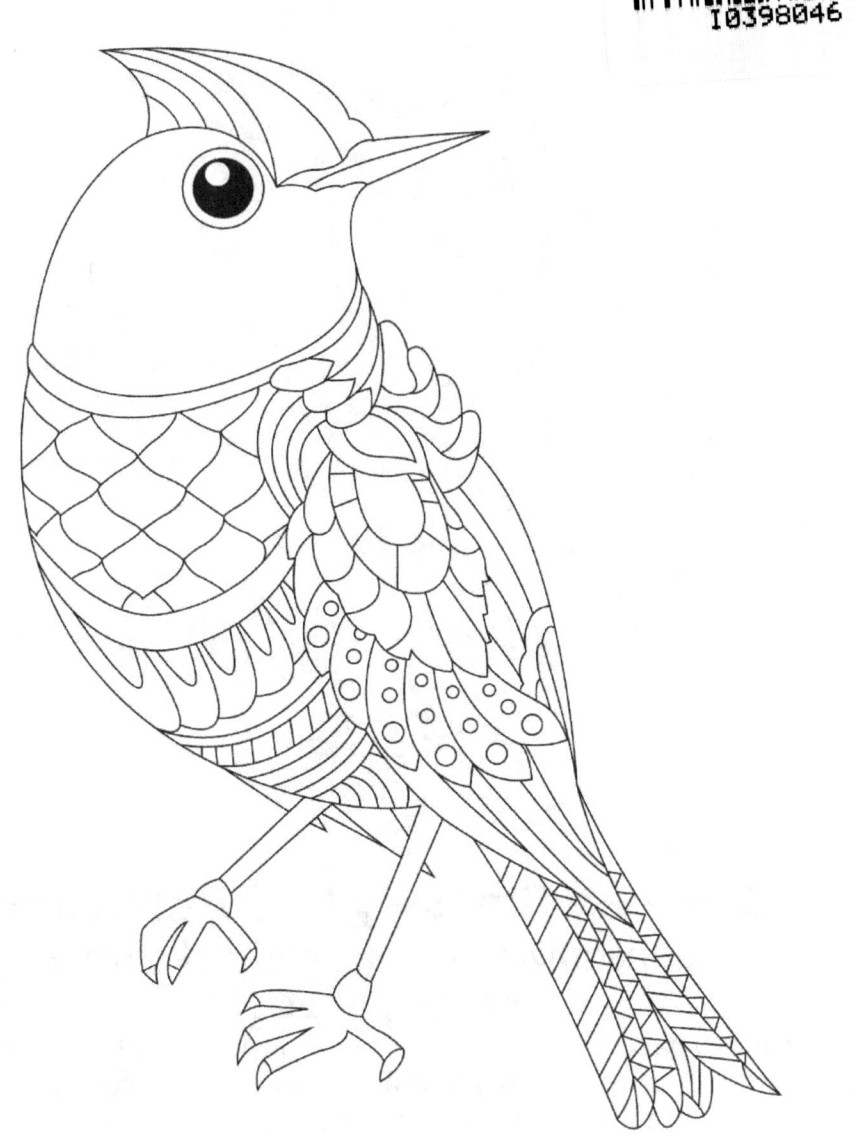

Get Your Free Butterfly Mandala Coloring Book

Visit

HTTPS://WWW.ADULTCOLORINGBOOKSFORYOU.COM

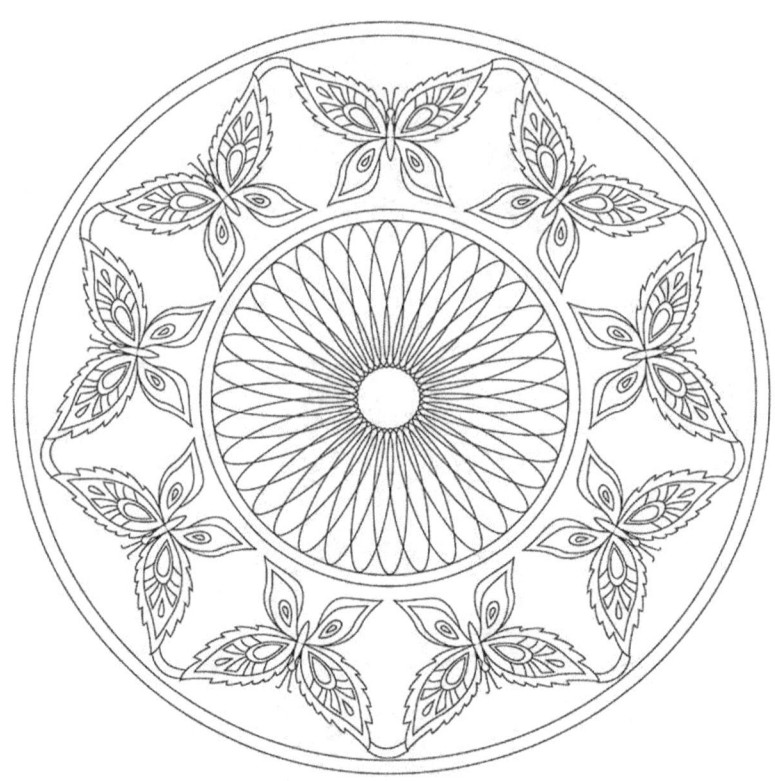

Make Profits Easy LLC Publishing
omarjohnson@adultcoloringbooksforyou.com
Copyright 2019

All rights reserved. No part of this book may be reproduced or transmitted in any form for any means, electronic or mechanical, including photocopying scanning and recording, or by any information storage and retrieval system, without permission in writing from the publisher except for the review for inclusion in a magazine, newspaper or broadcast.

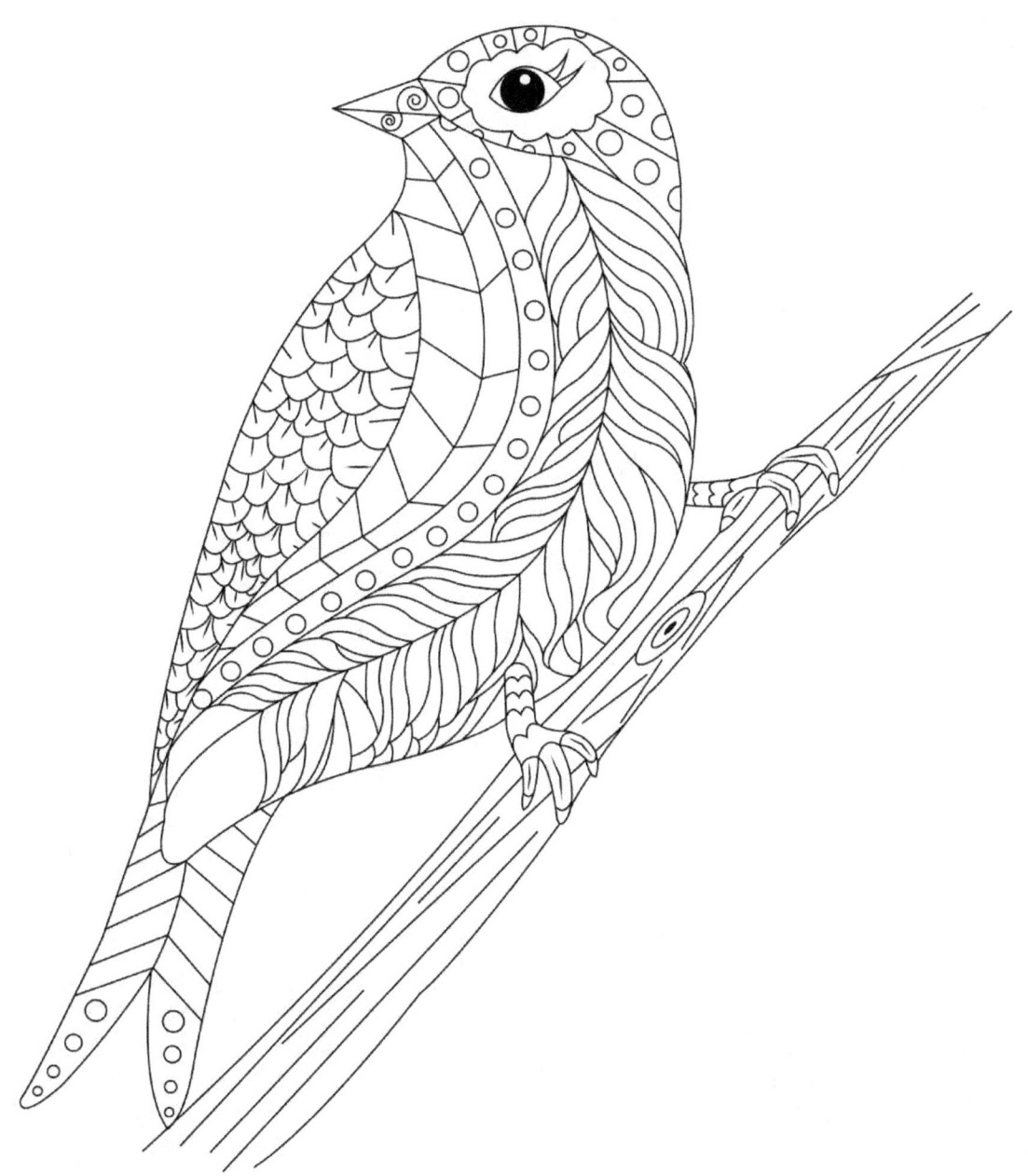

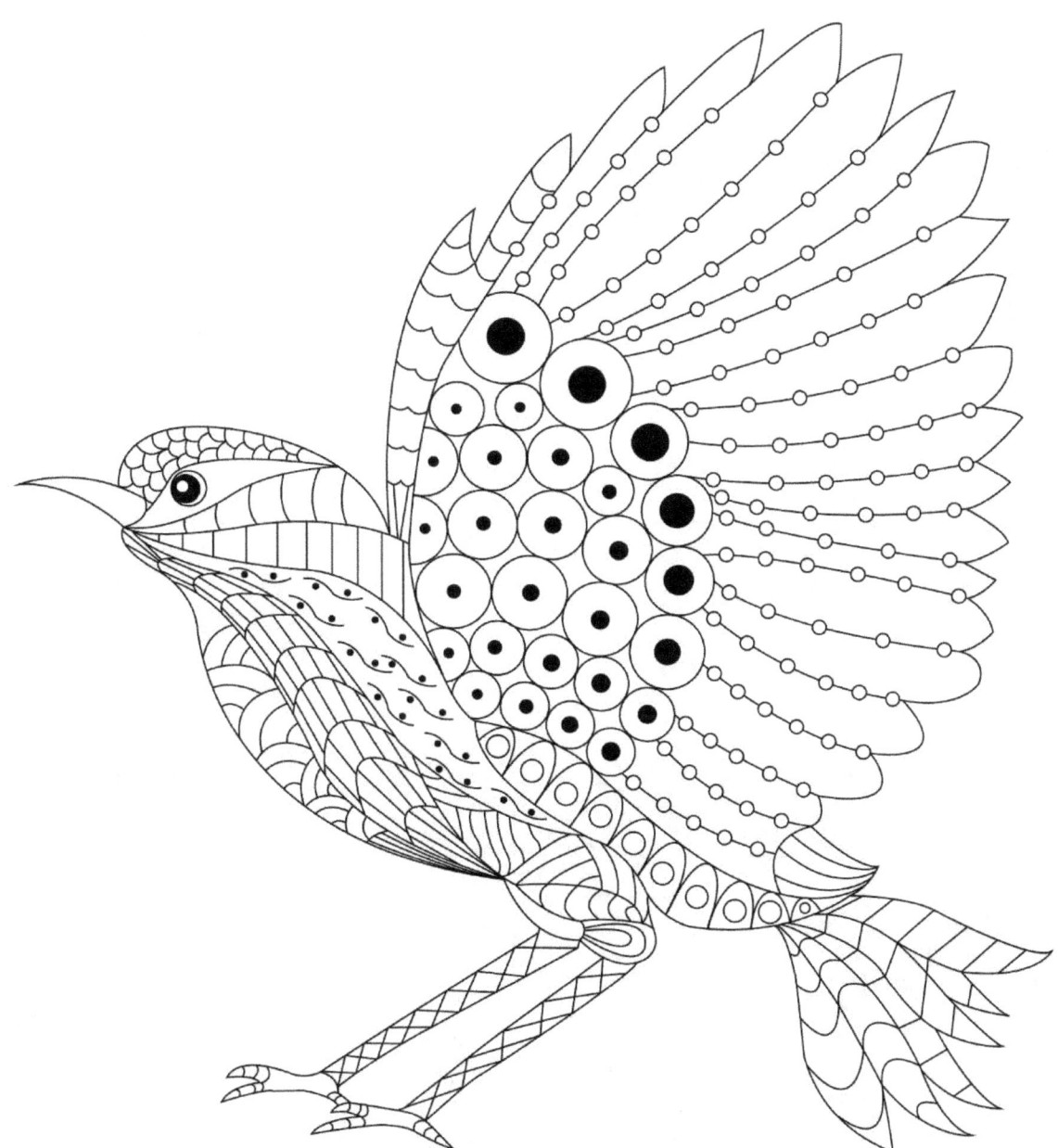

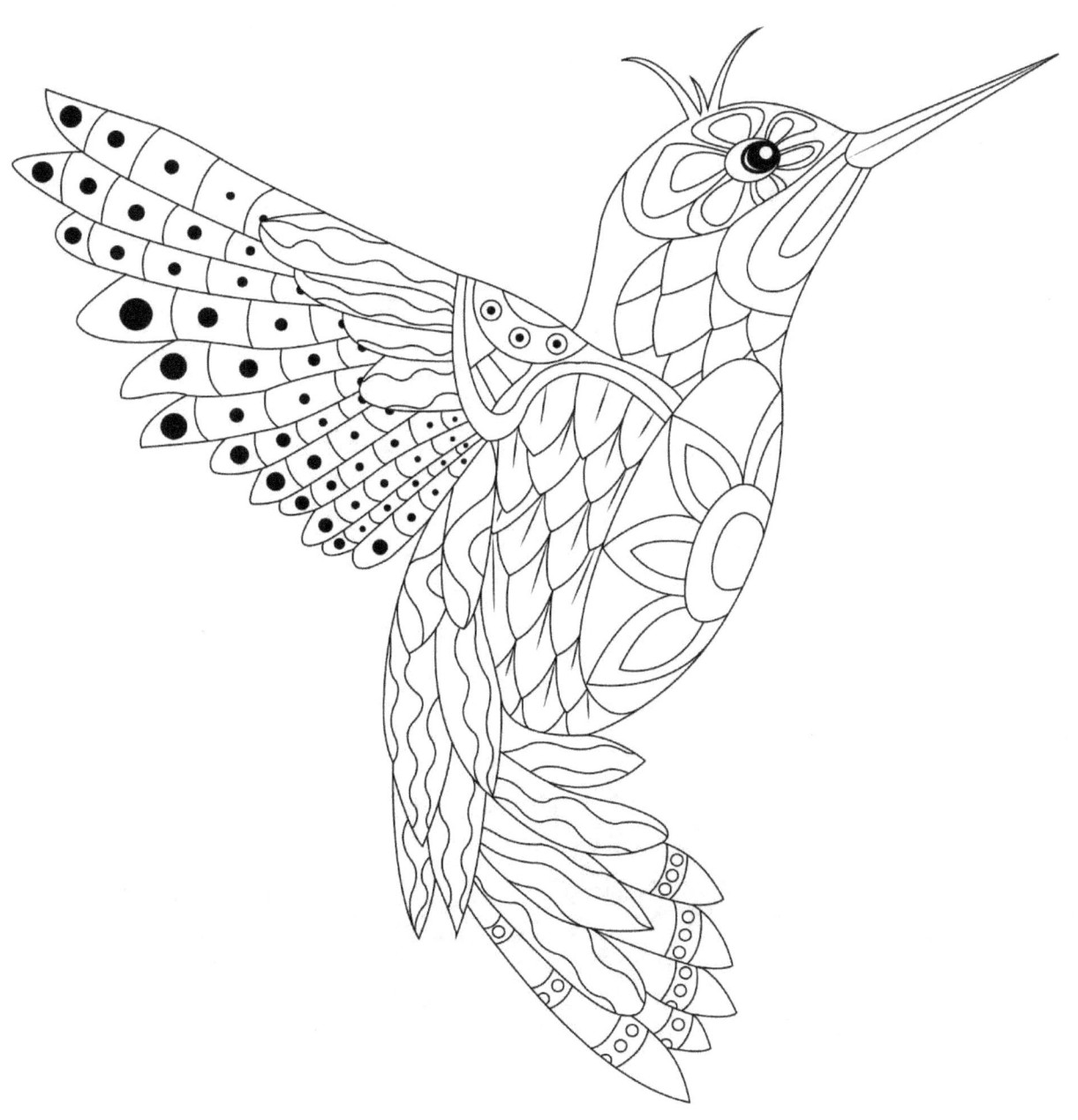

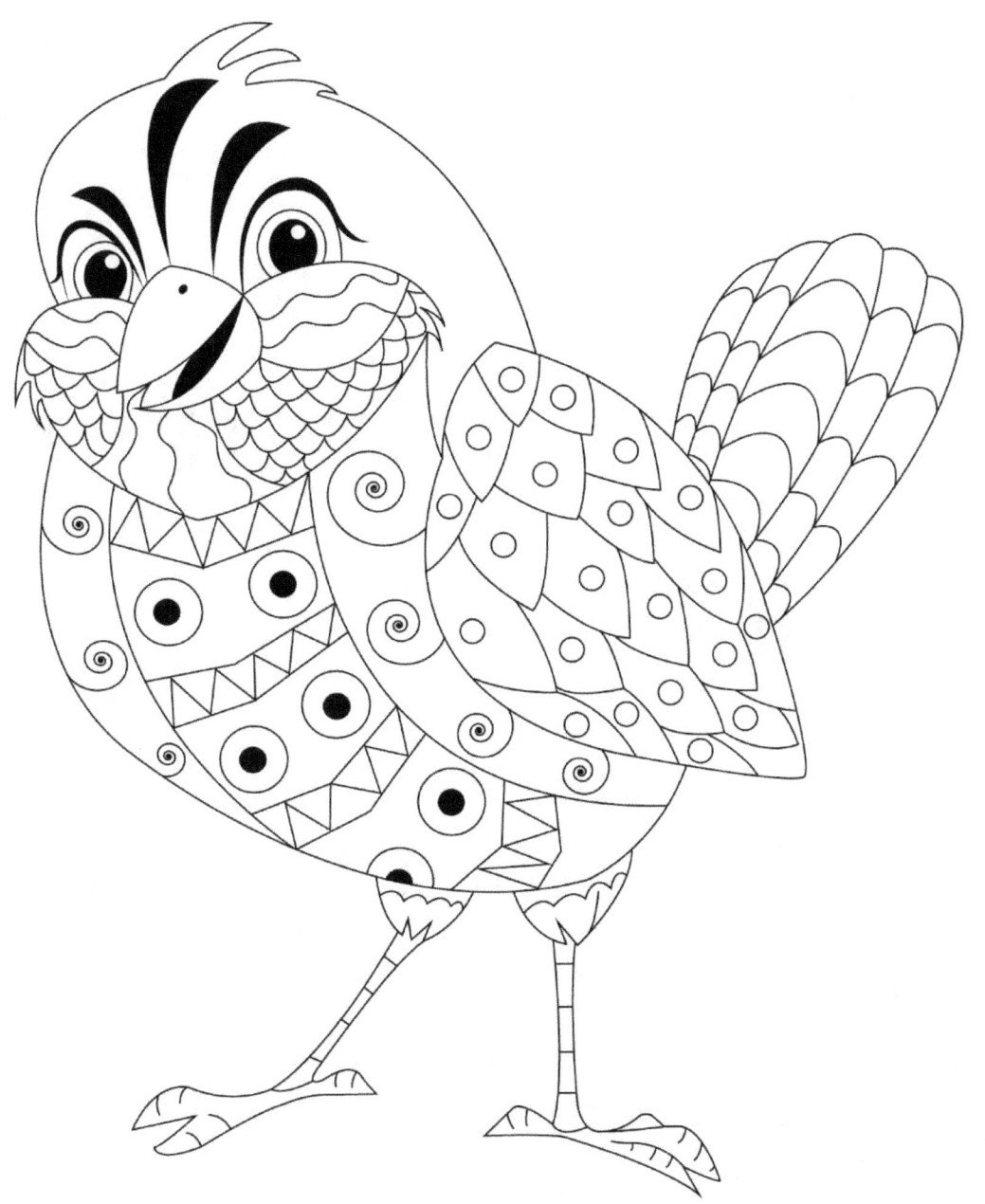

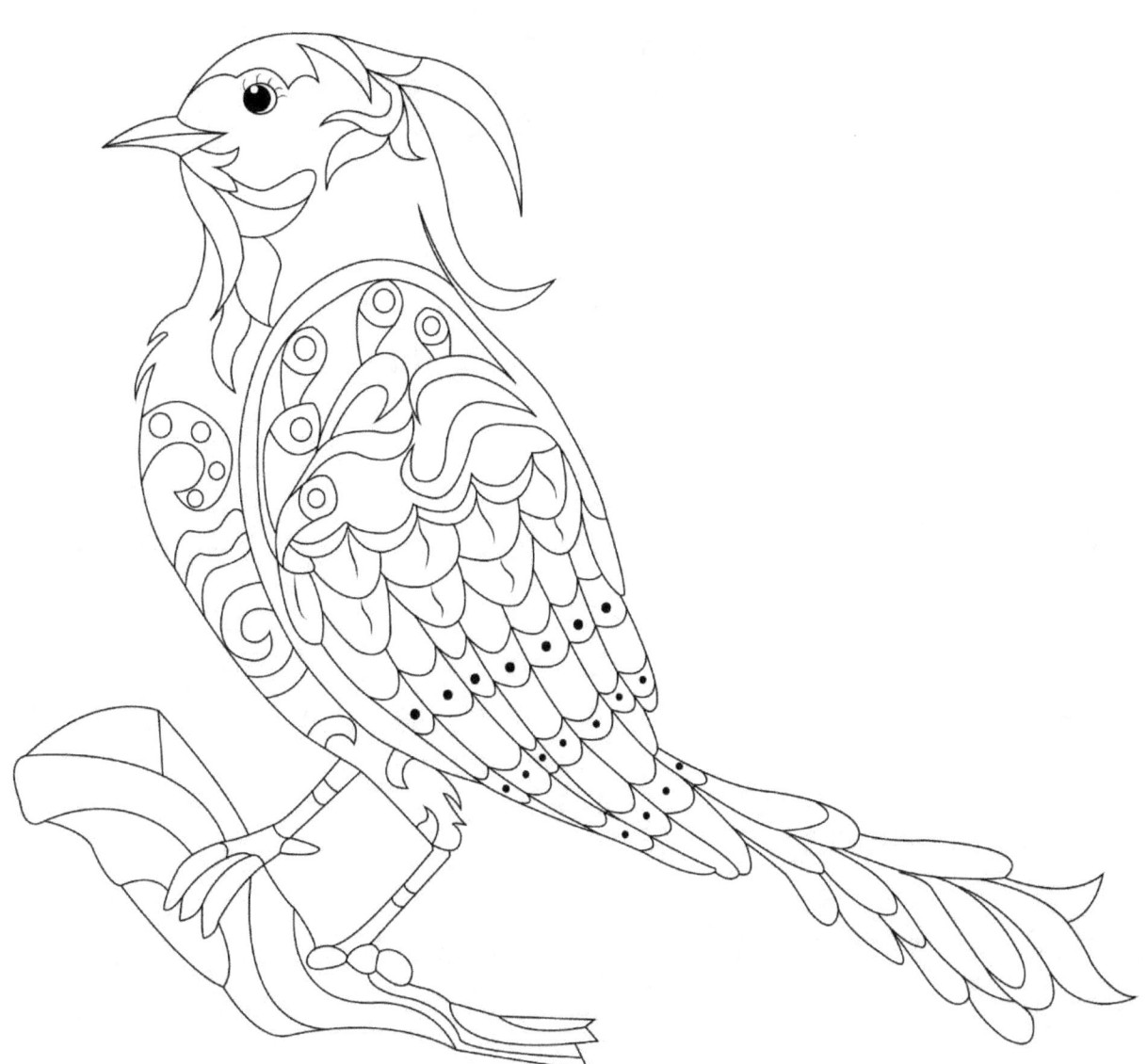

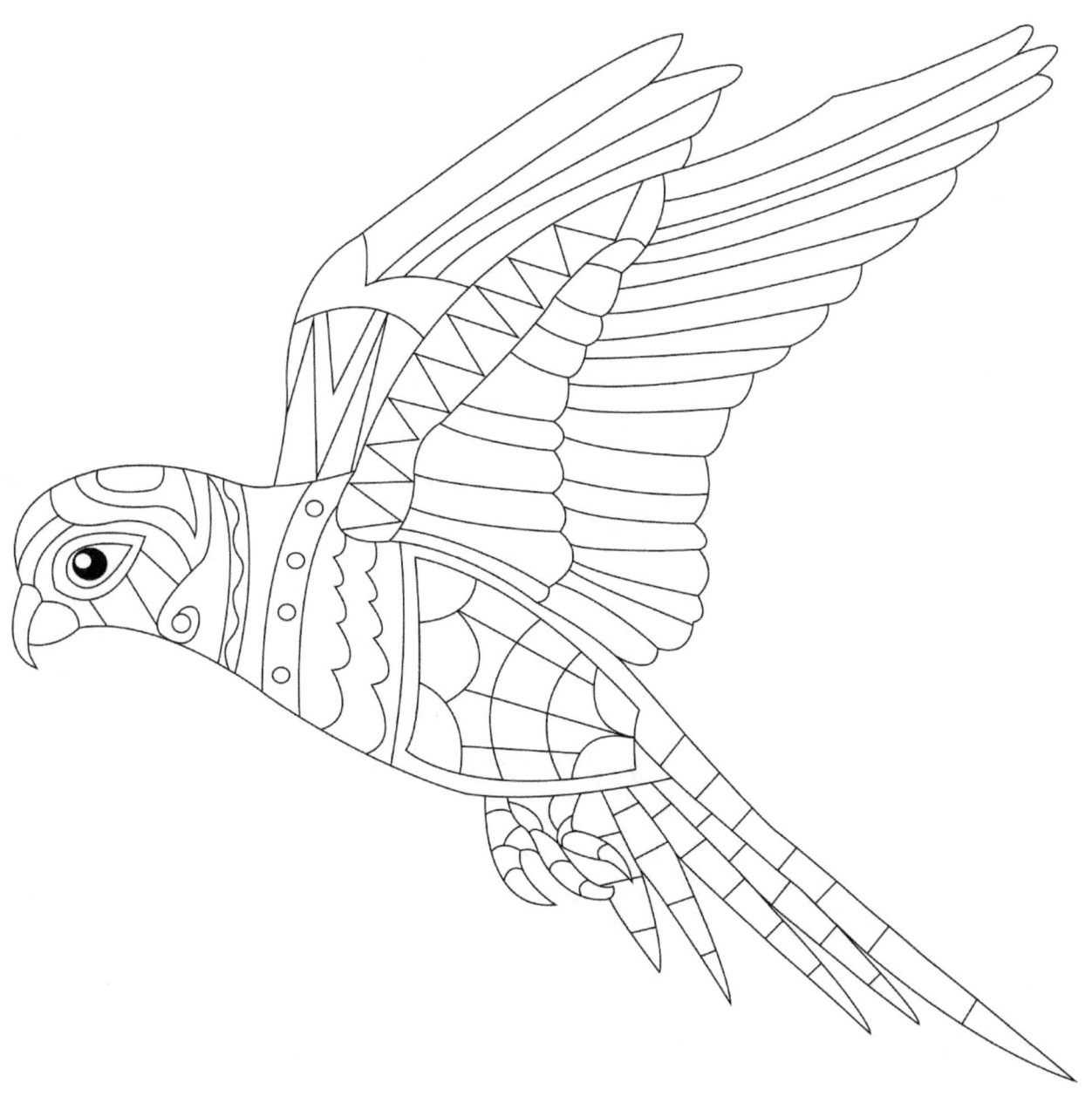

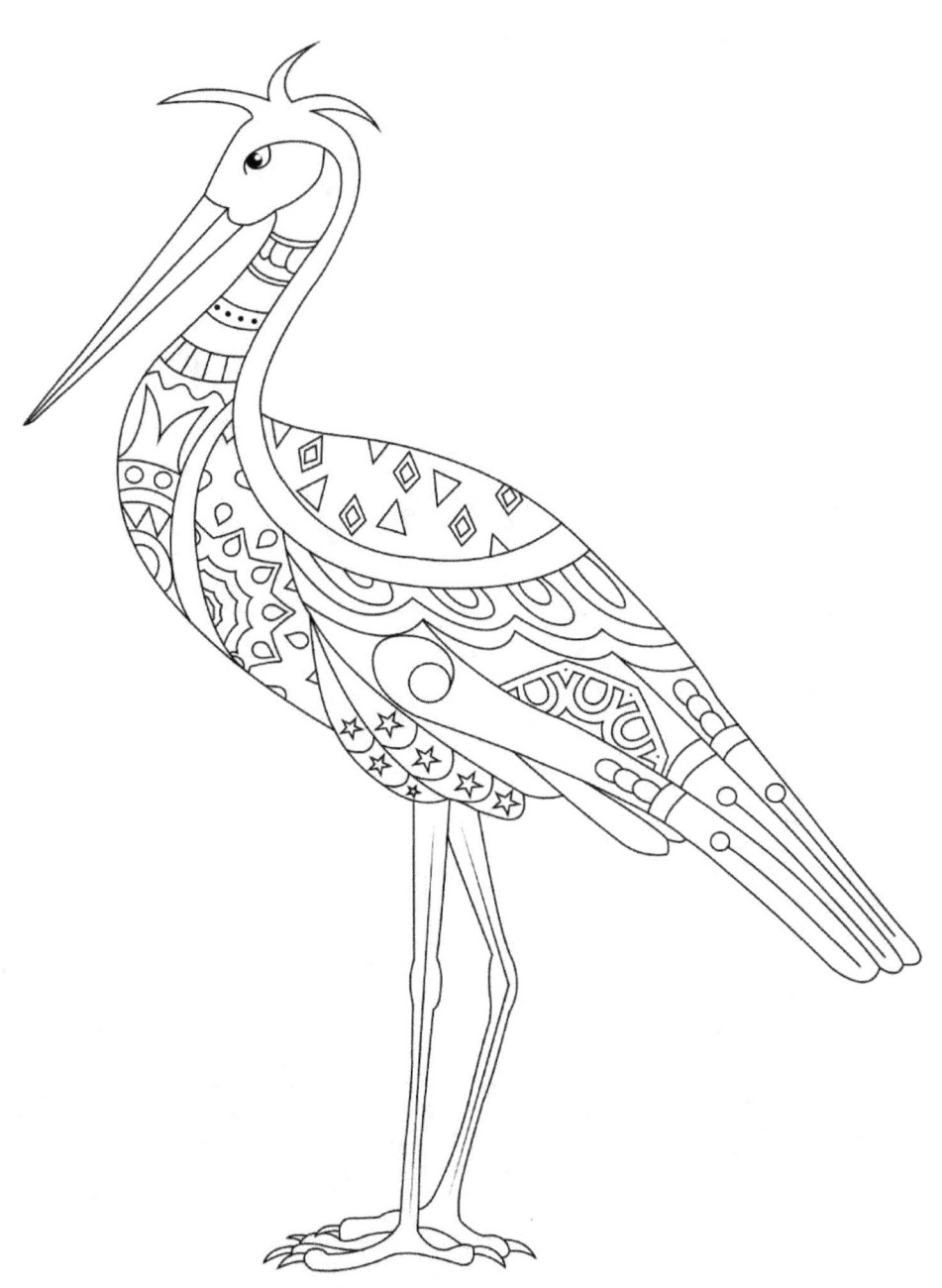

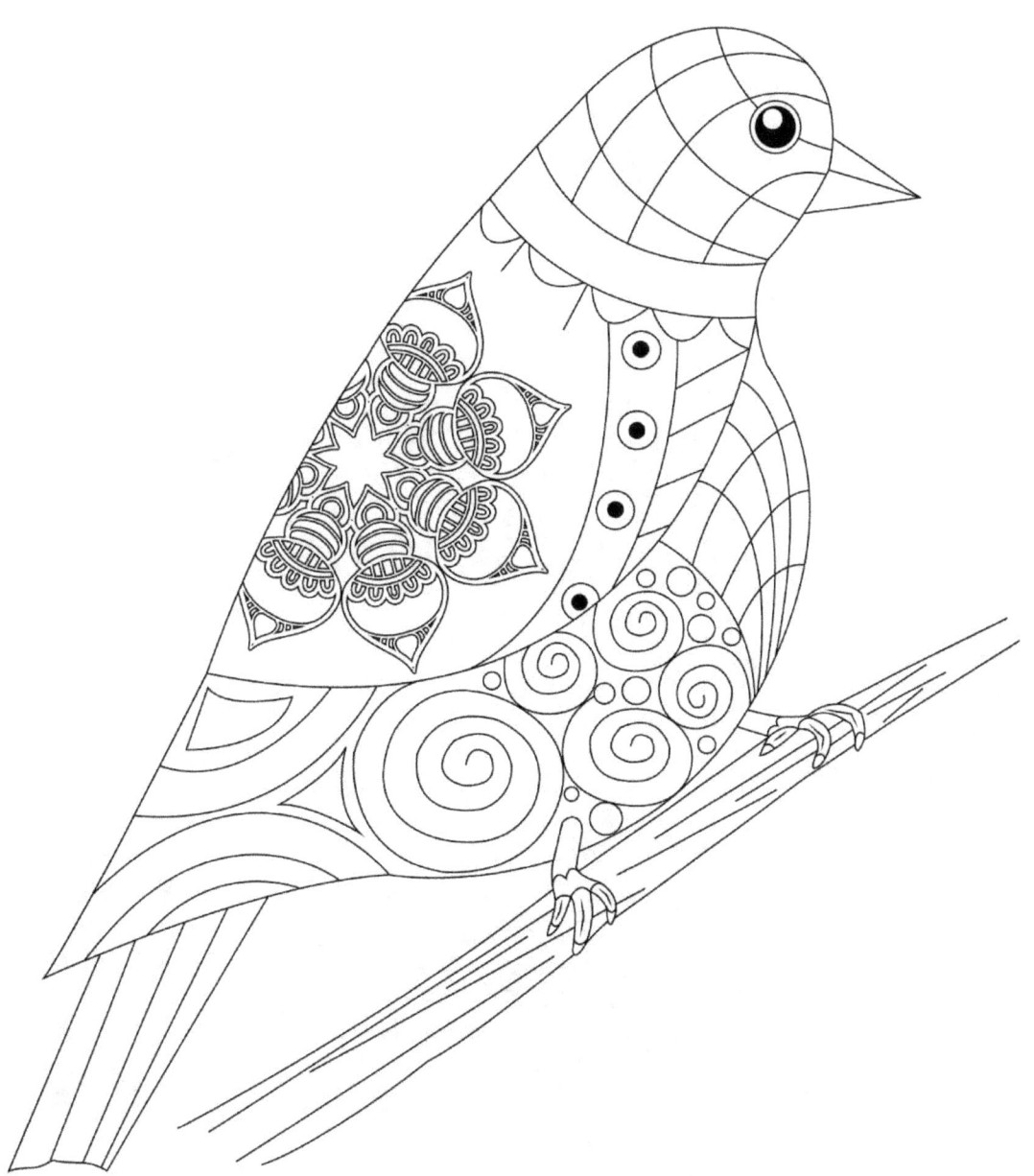

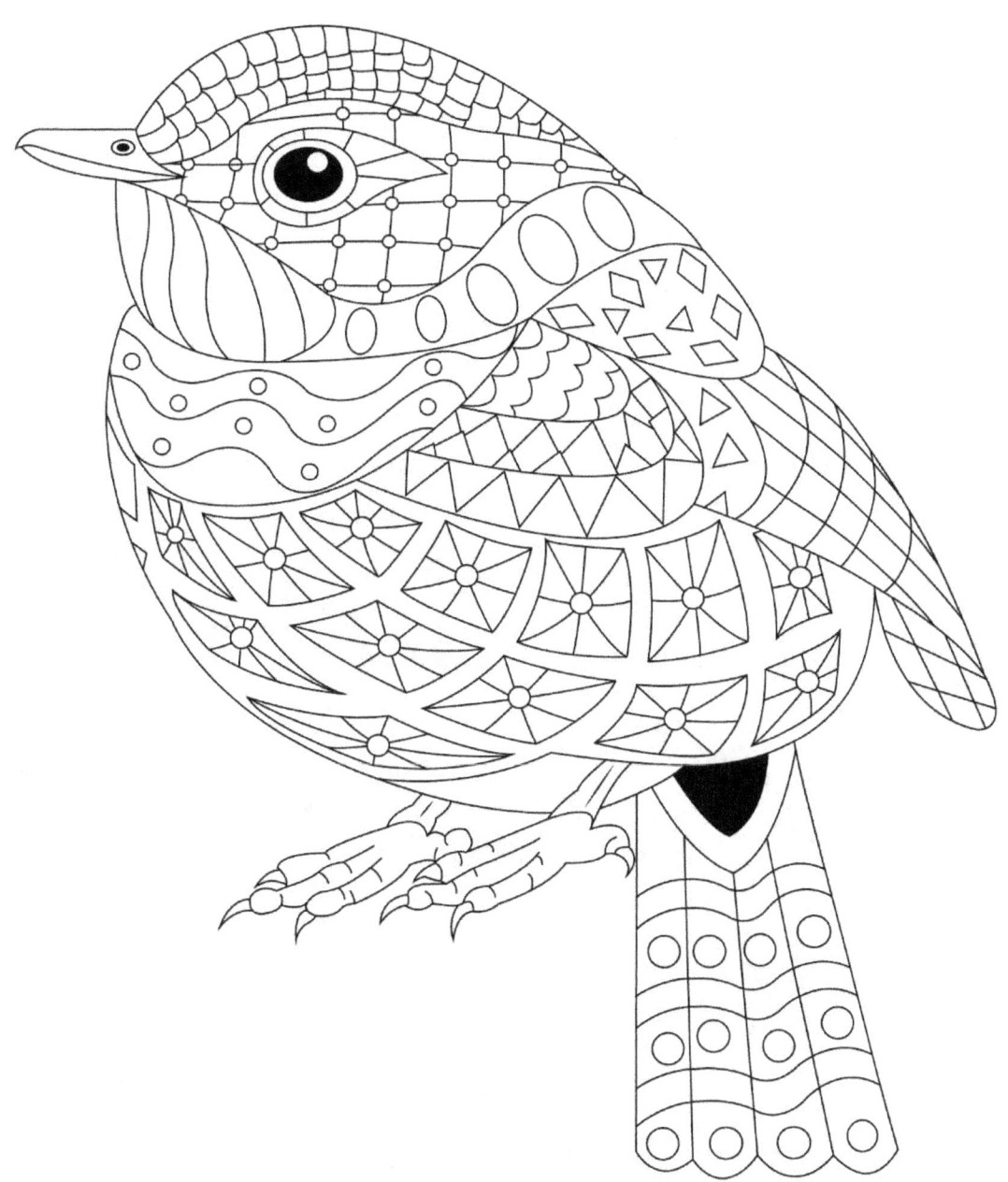

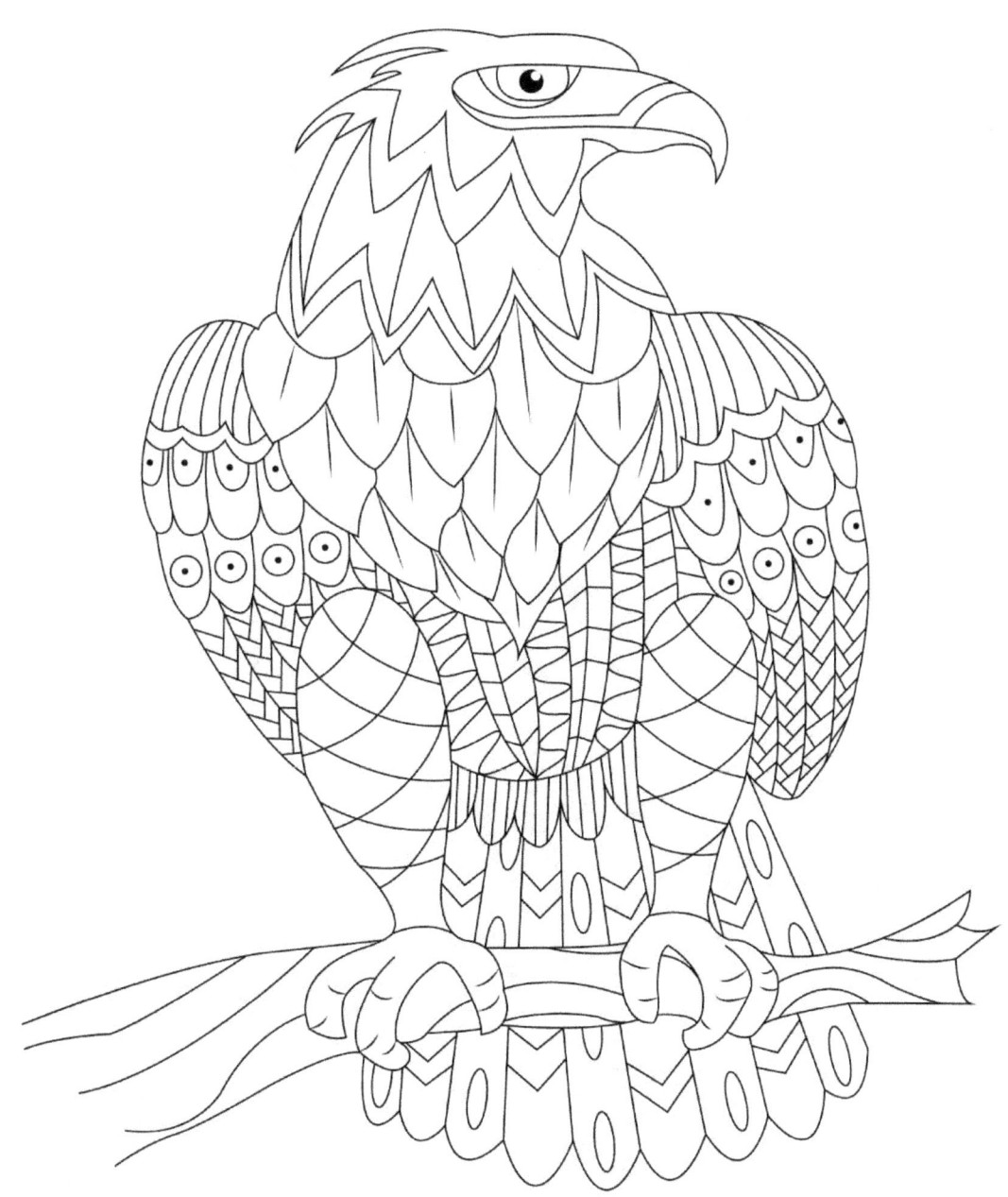

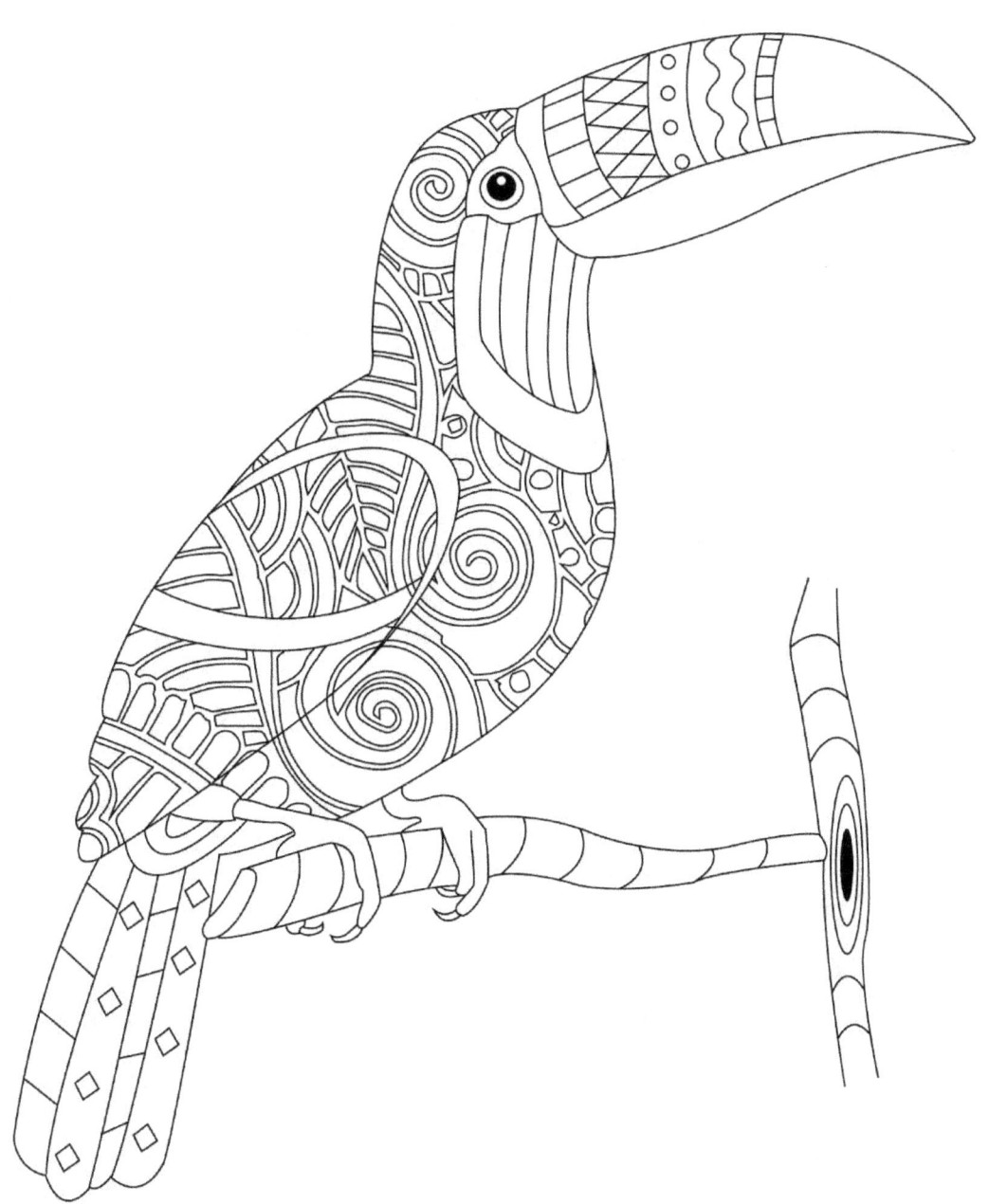

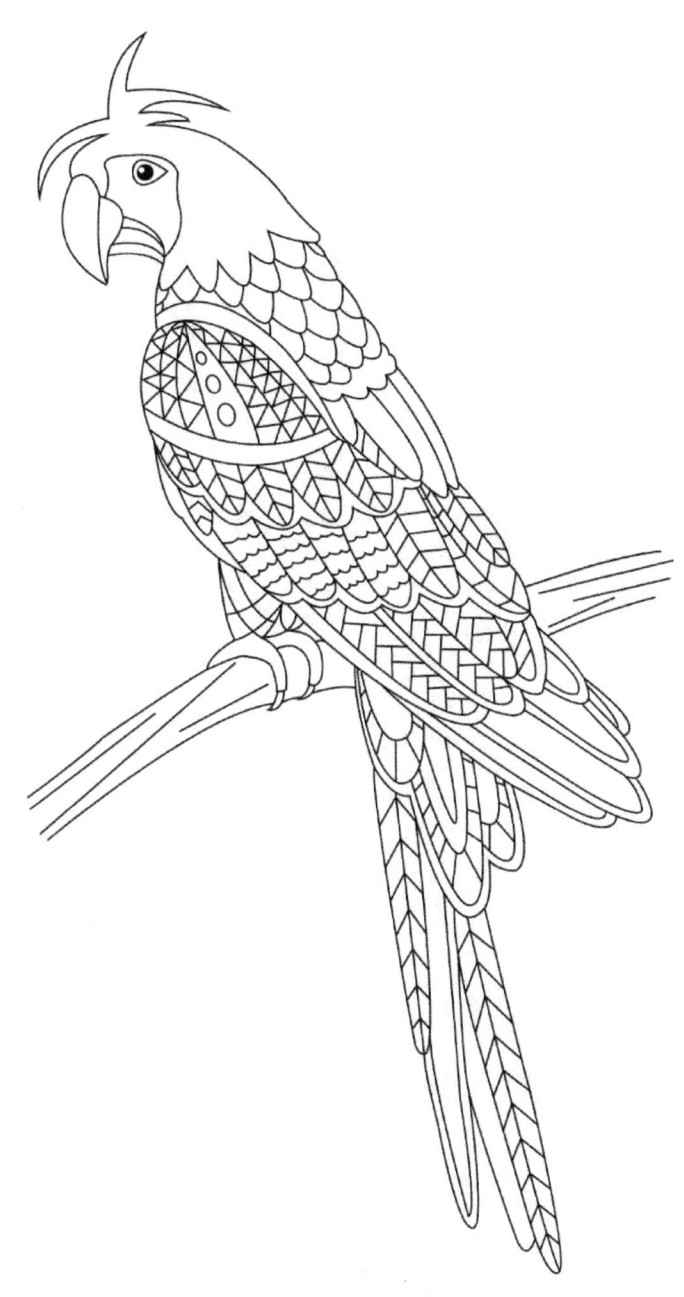

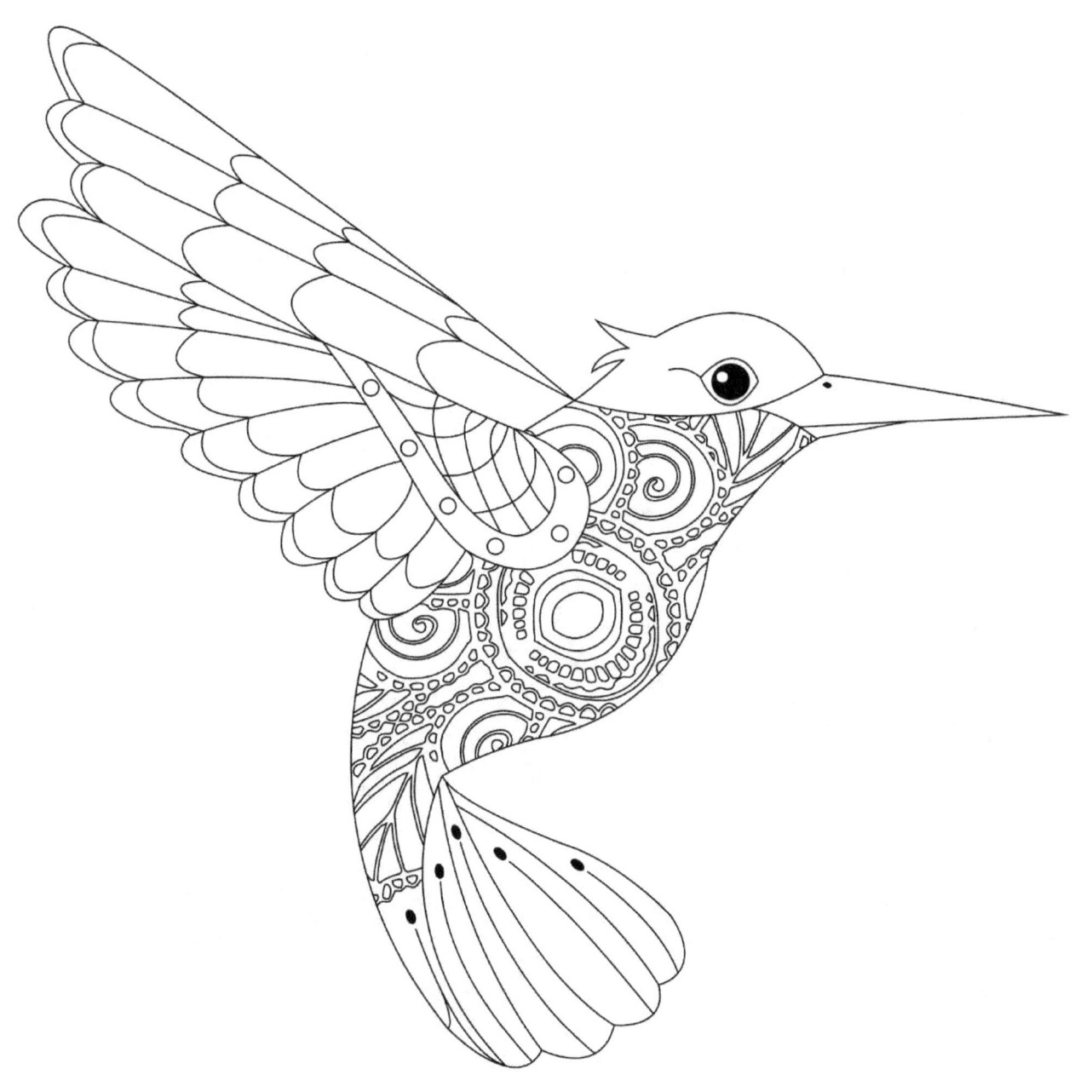

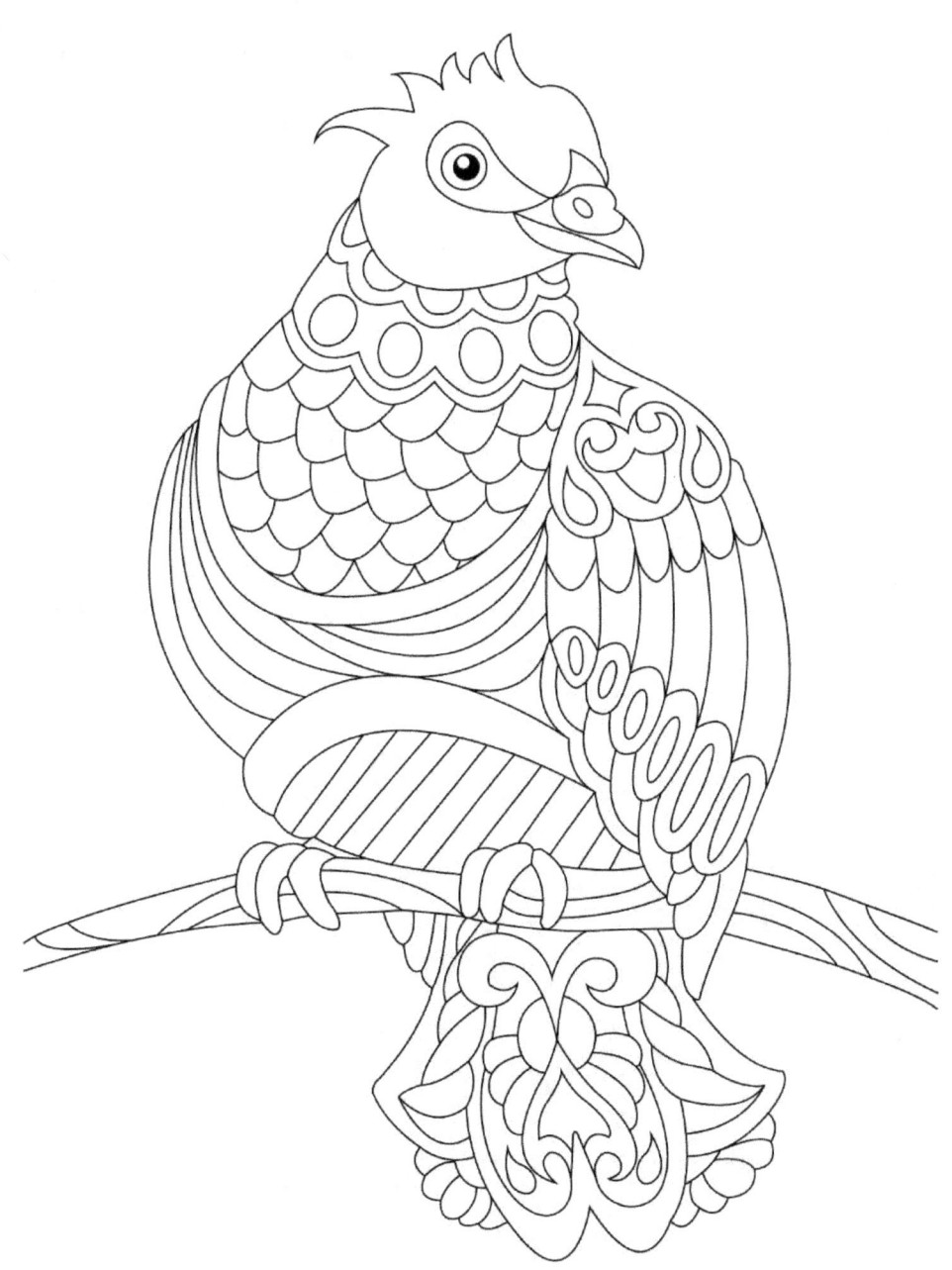

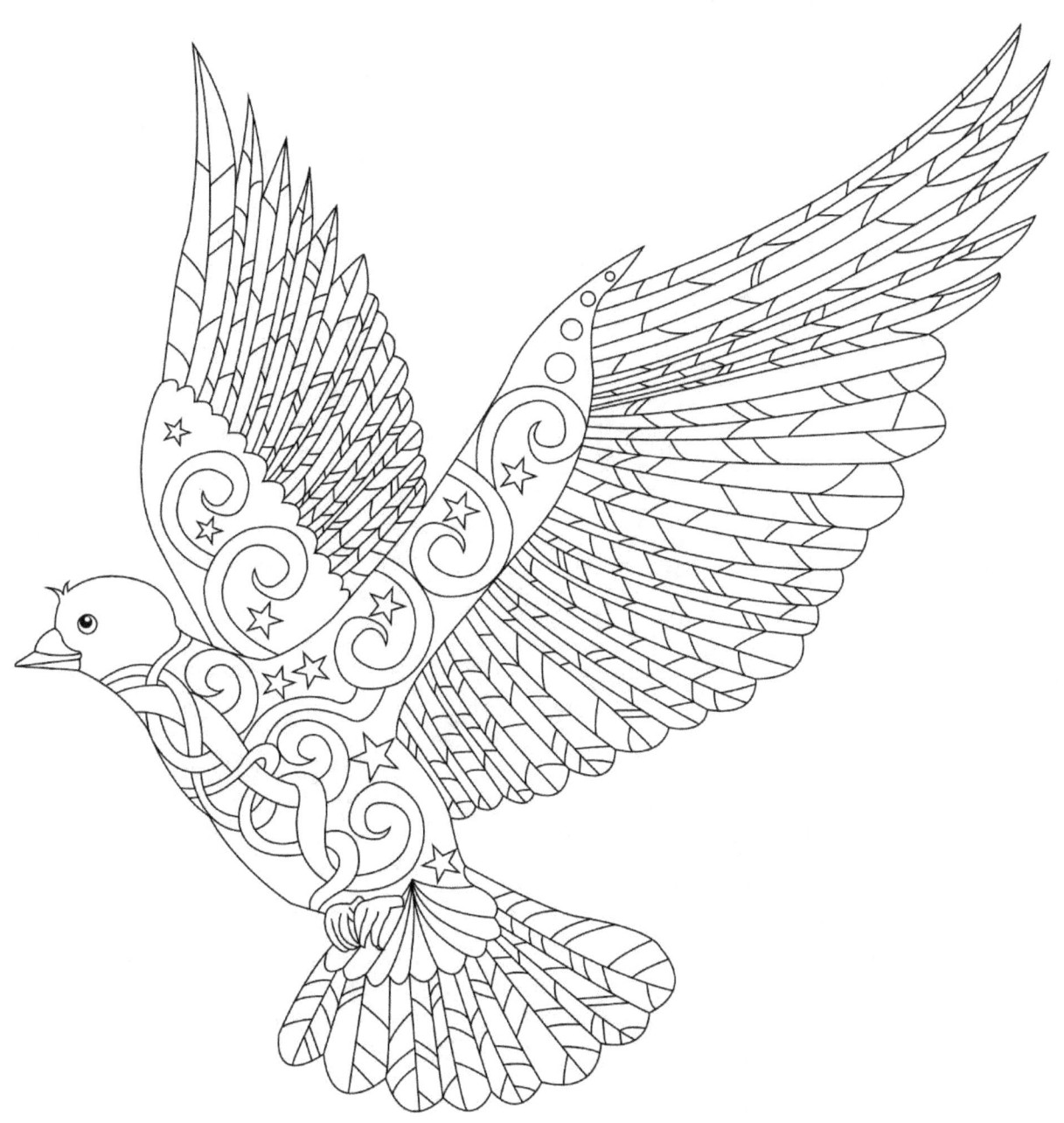

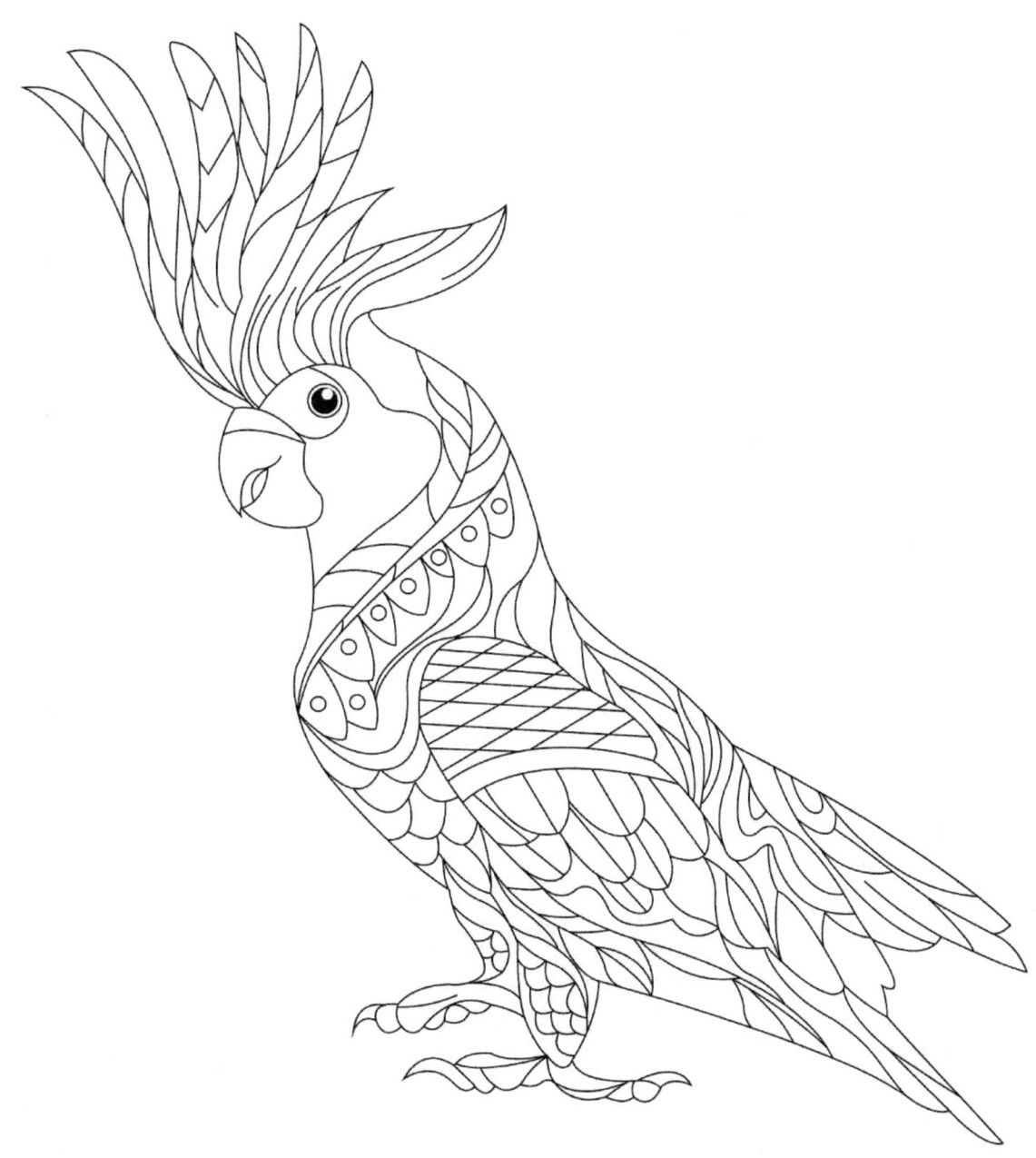

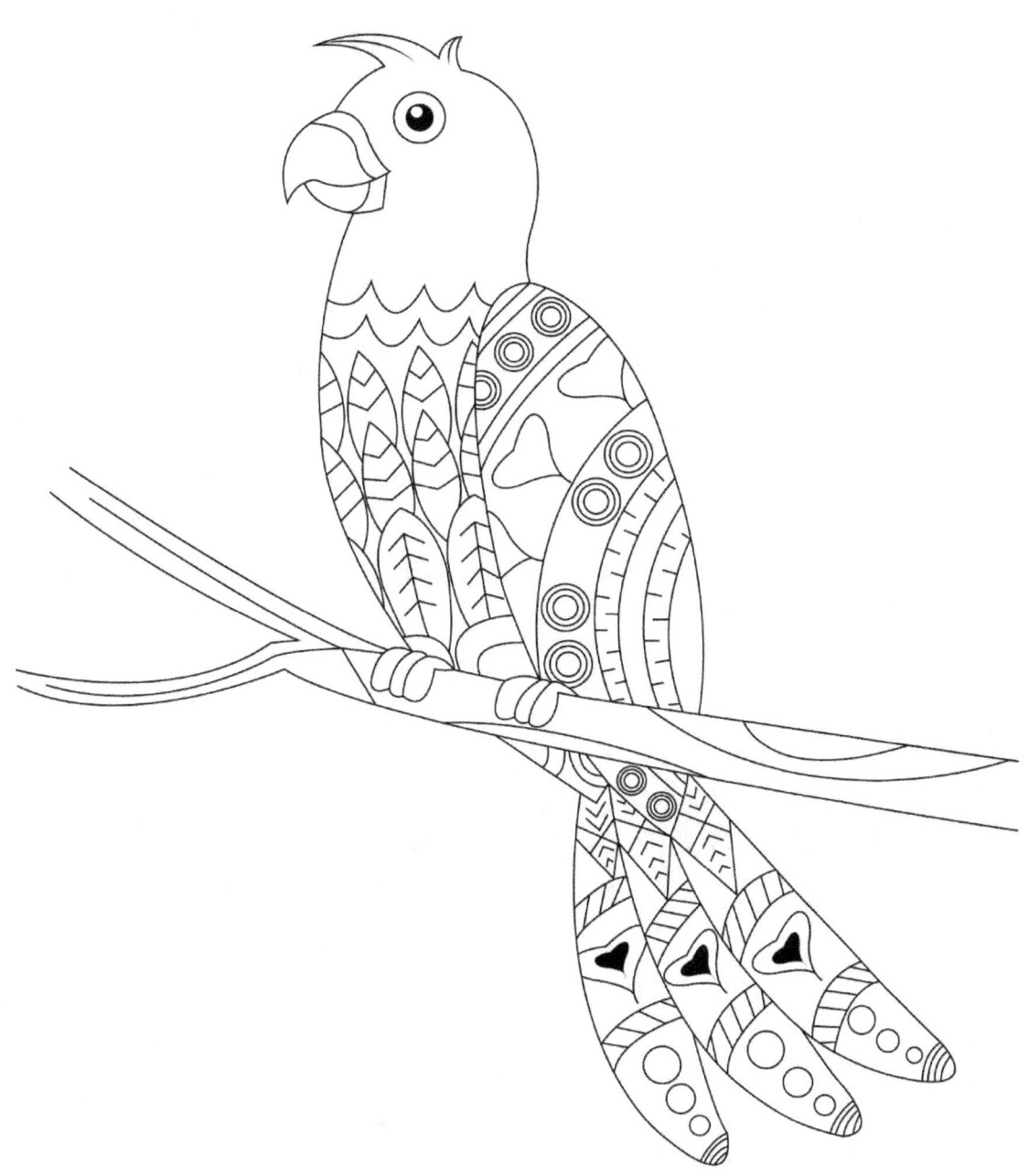

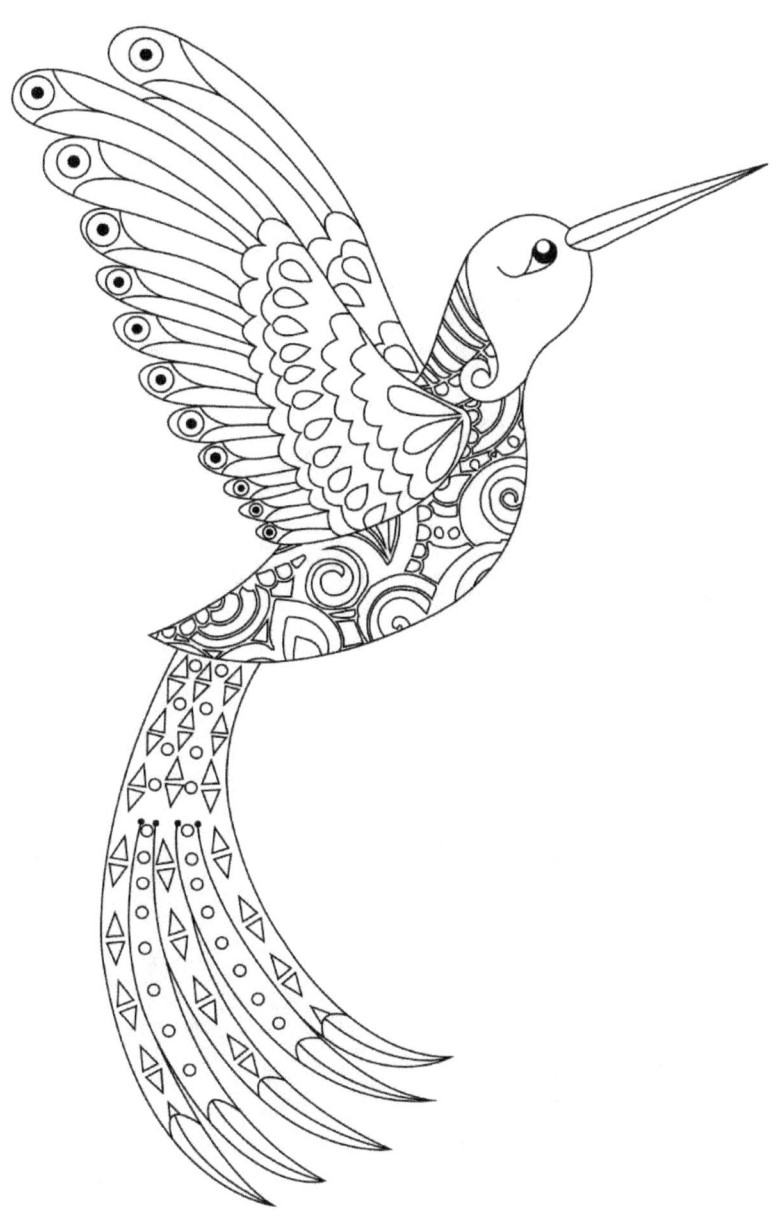

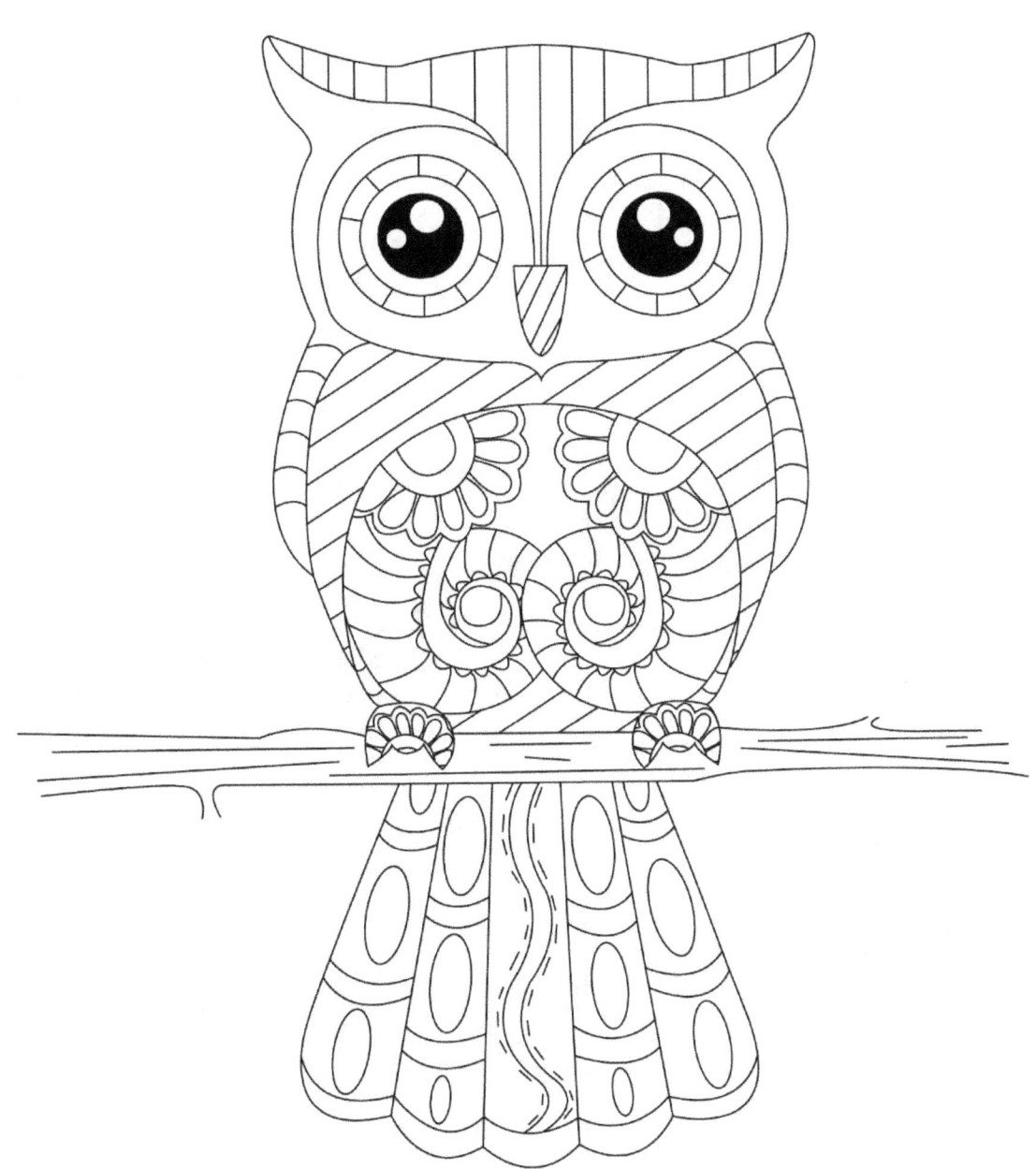

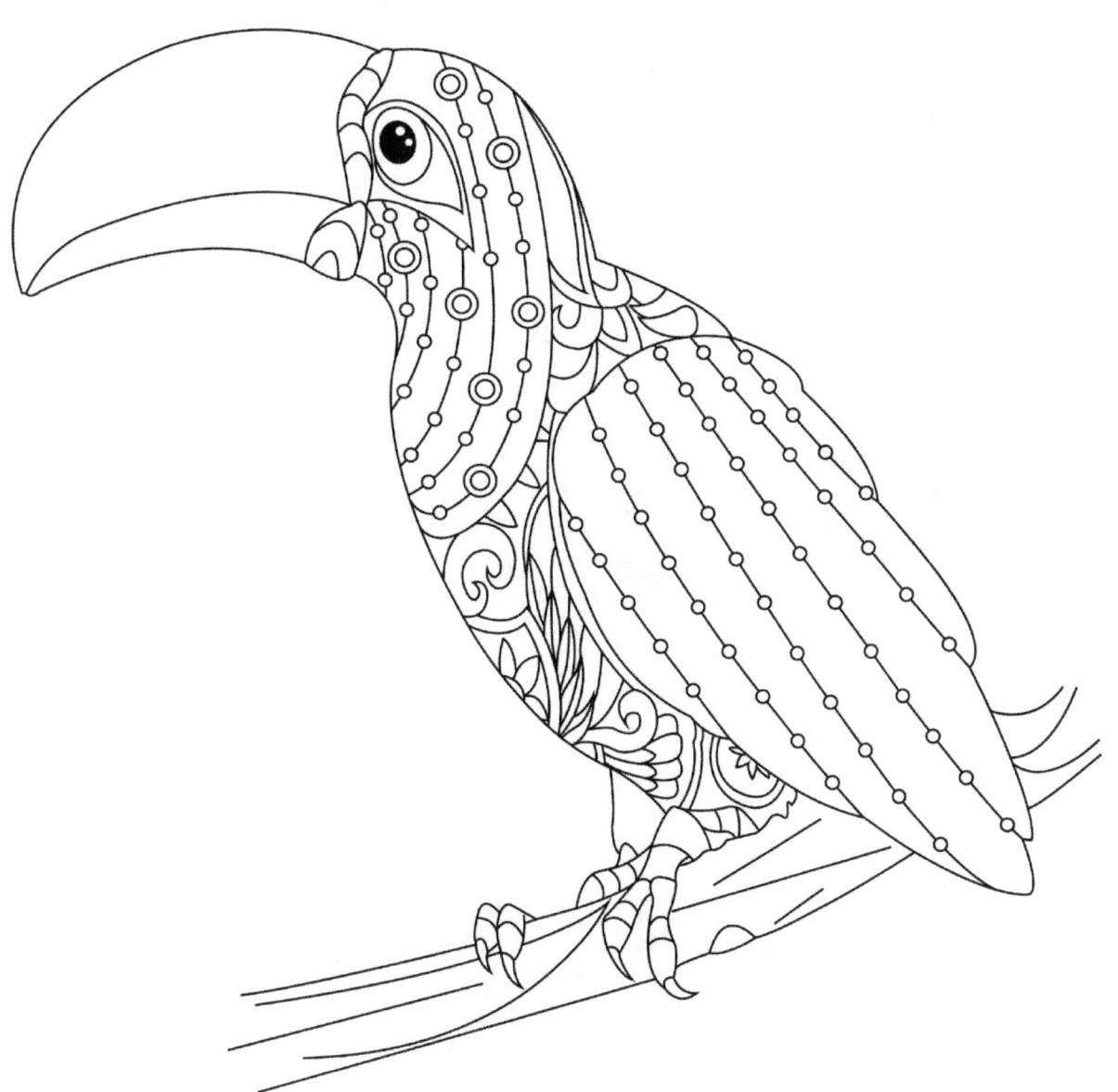

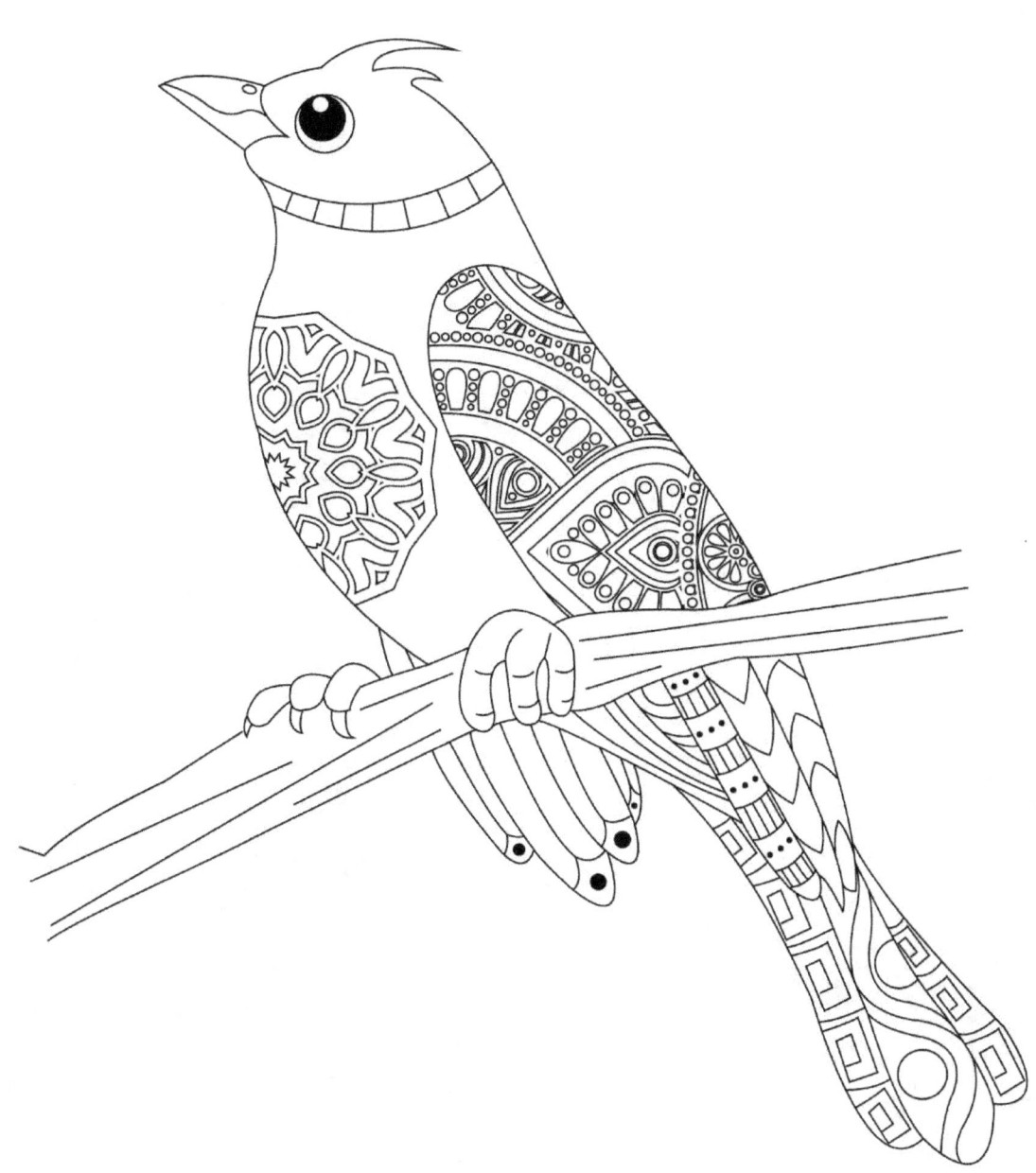

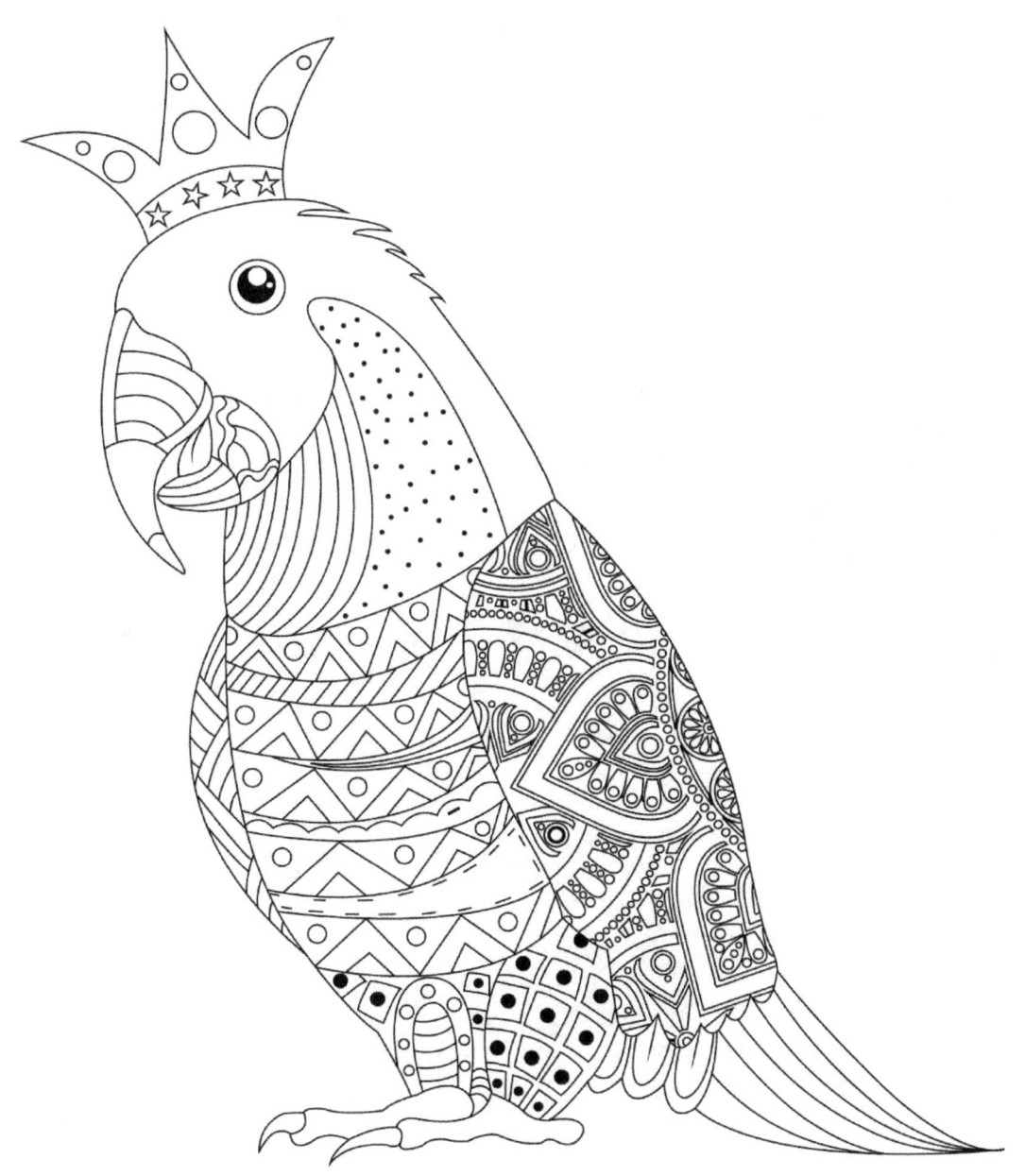

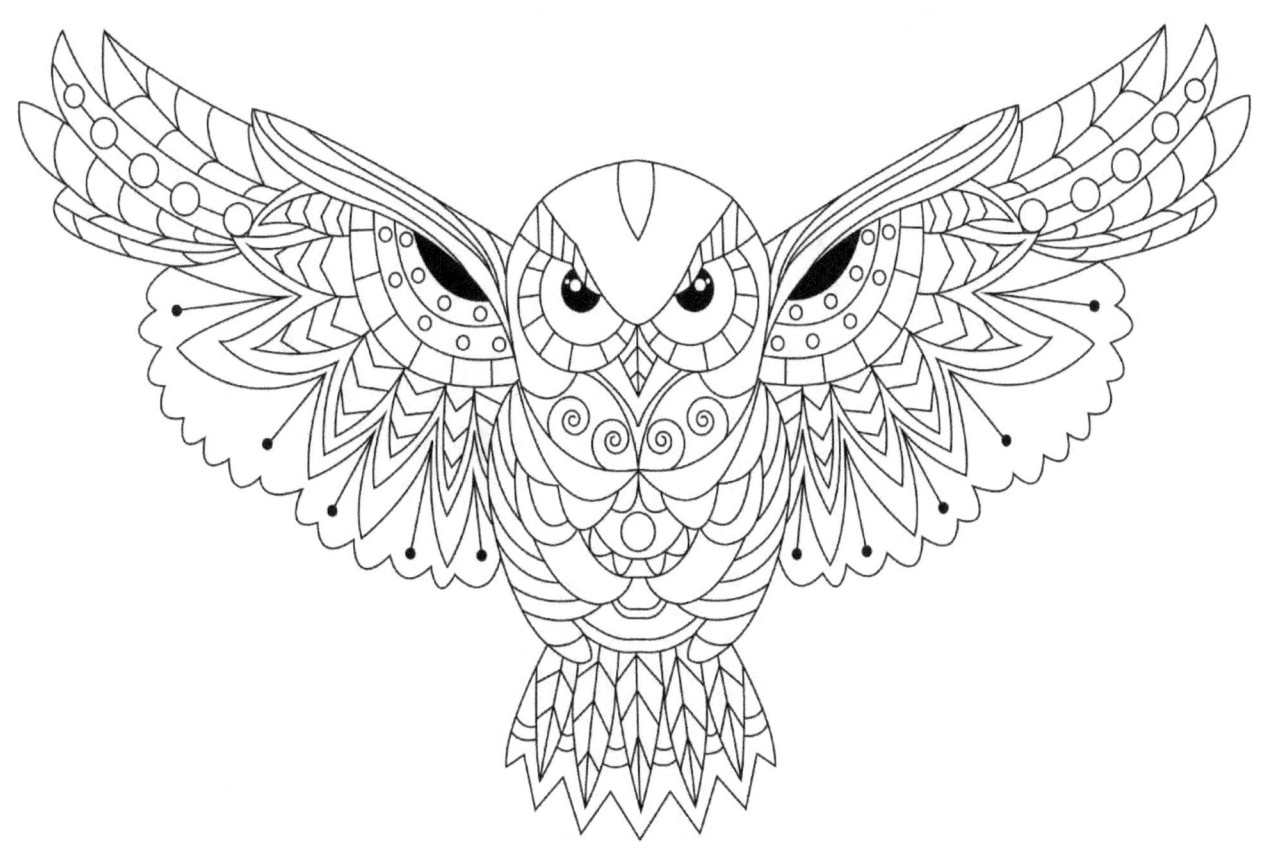

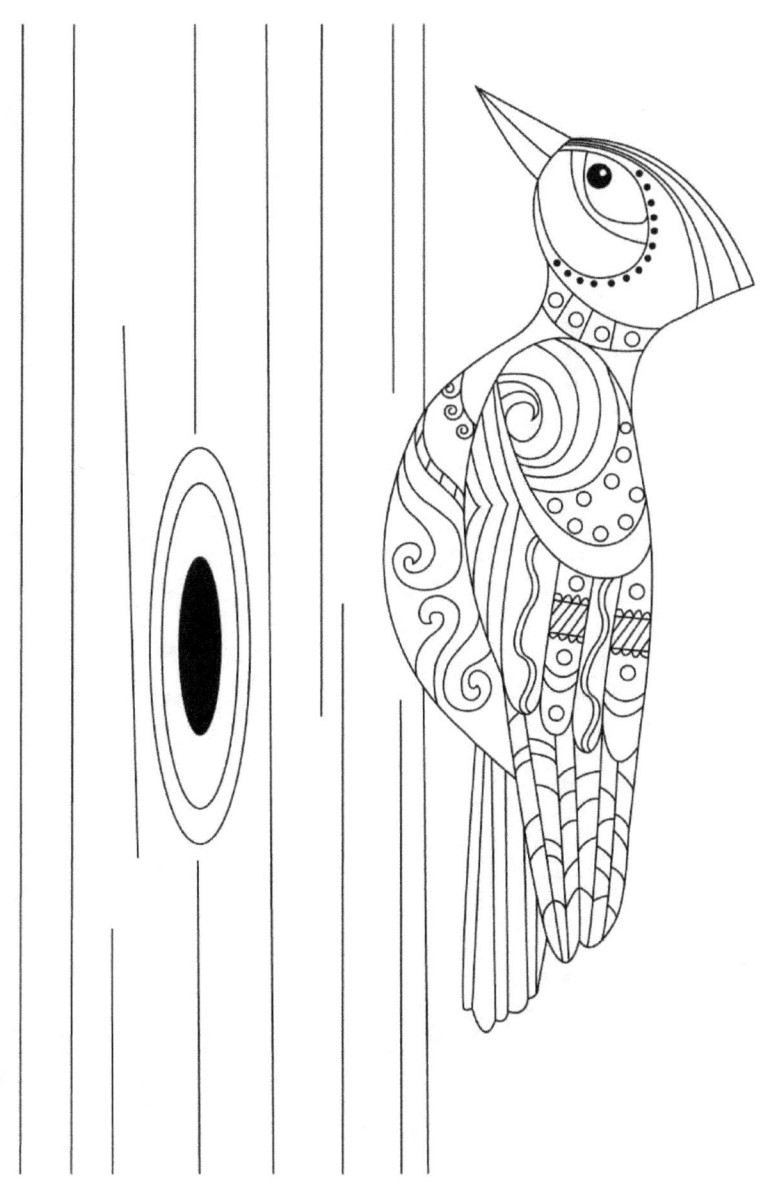

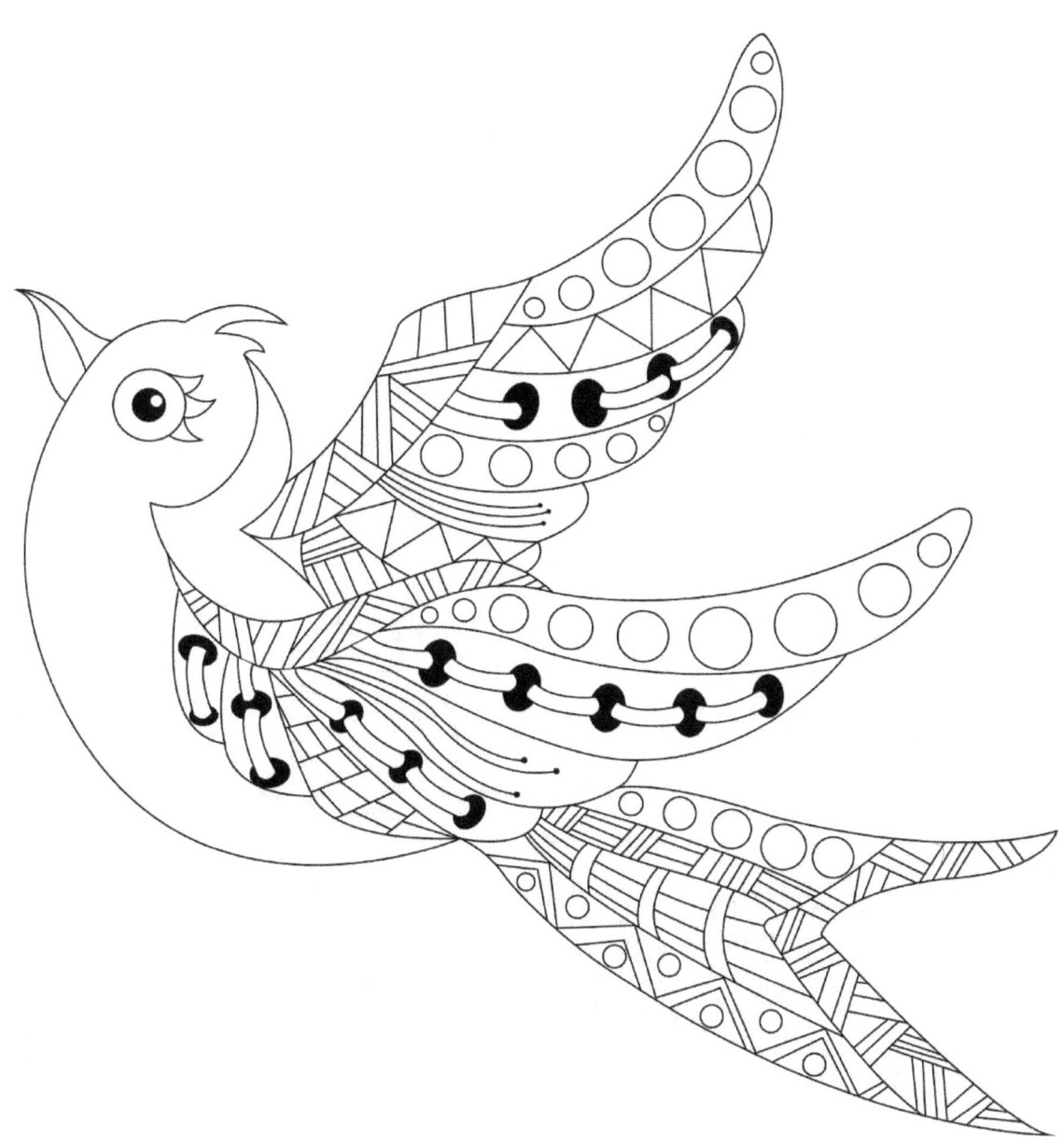

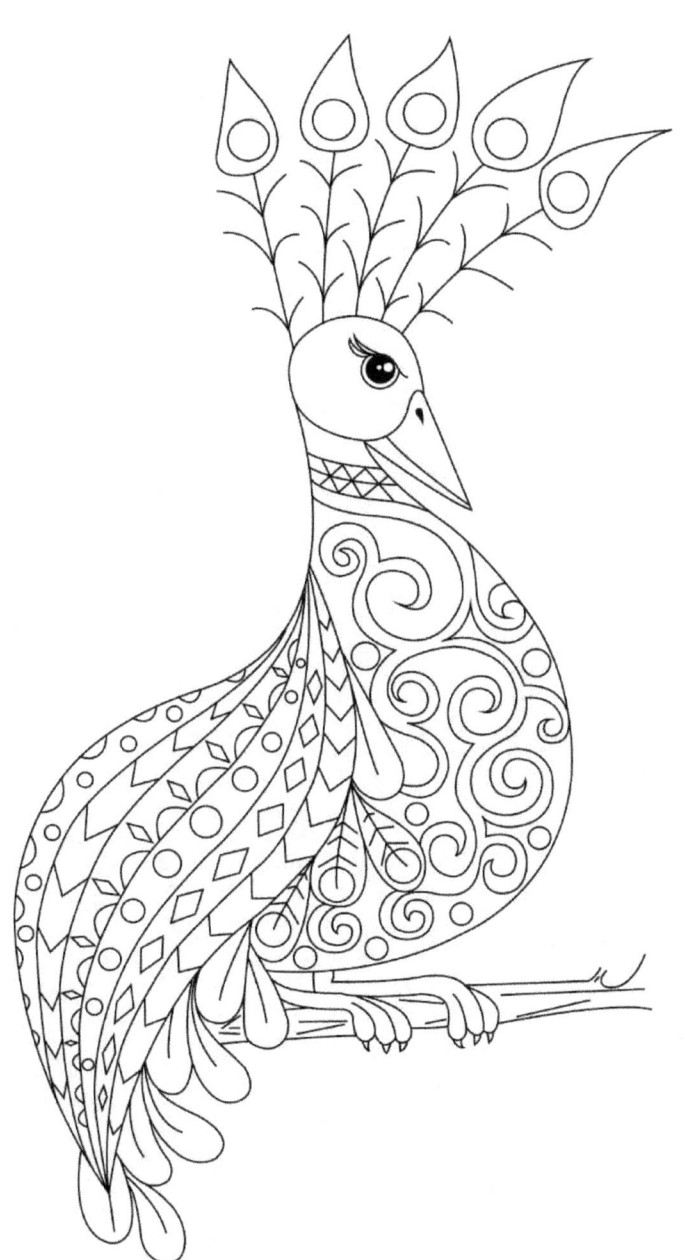

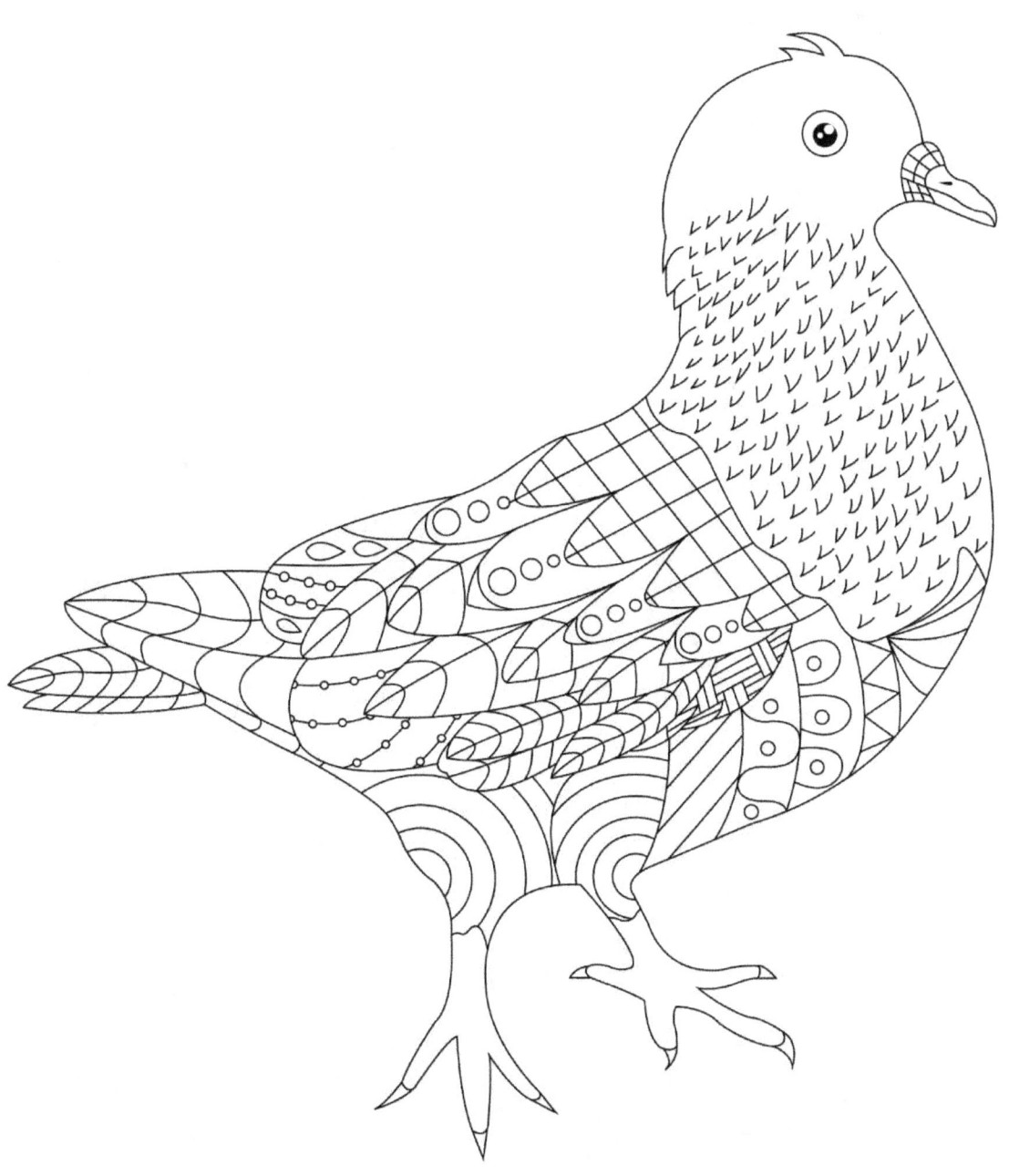

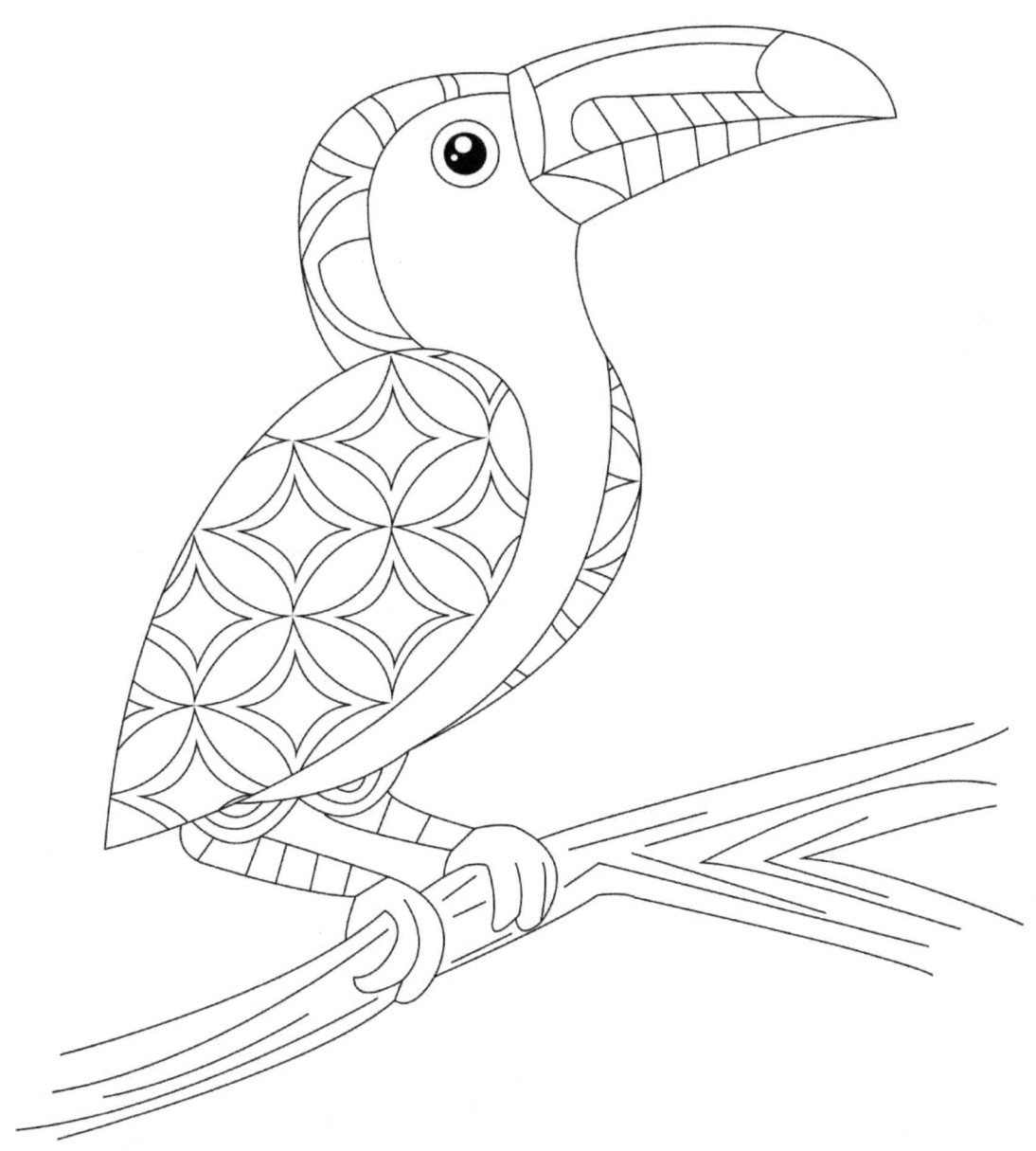

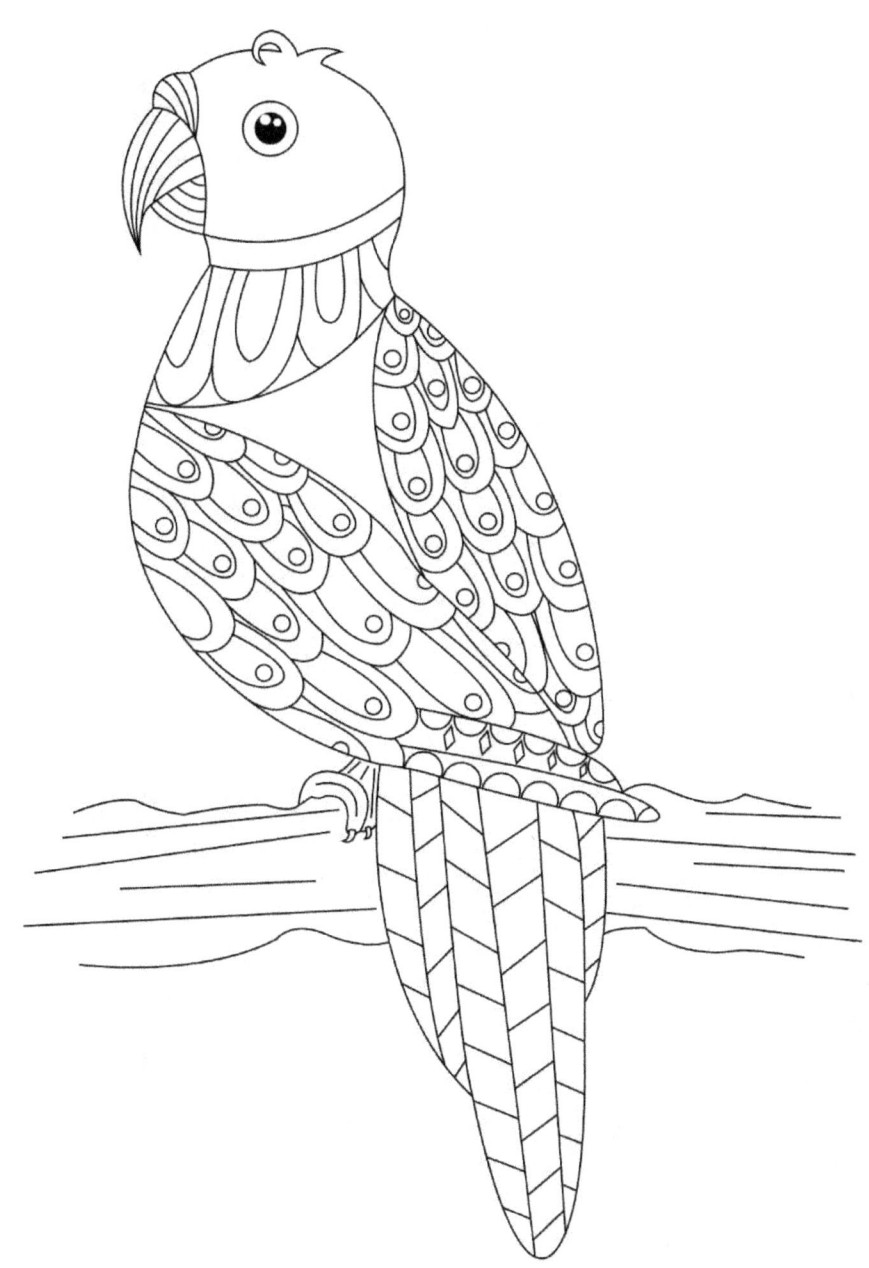

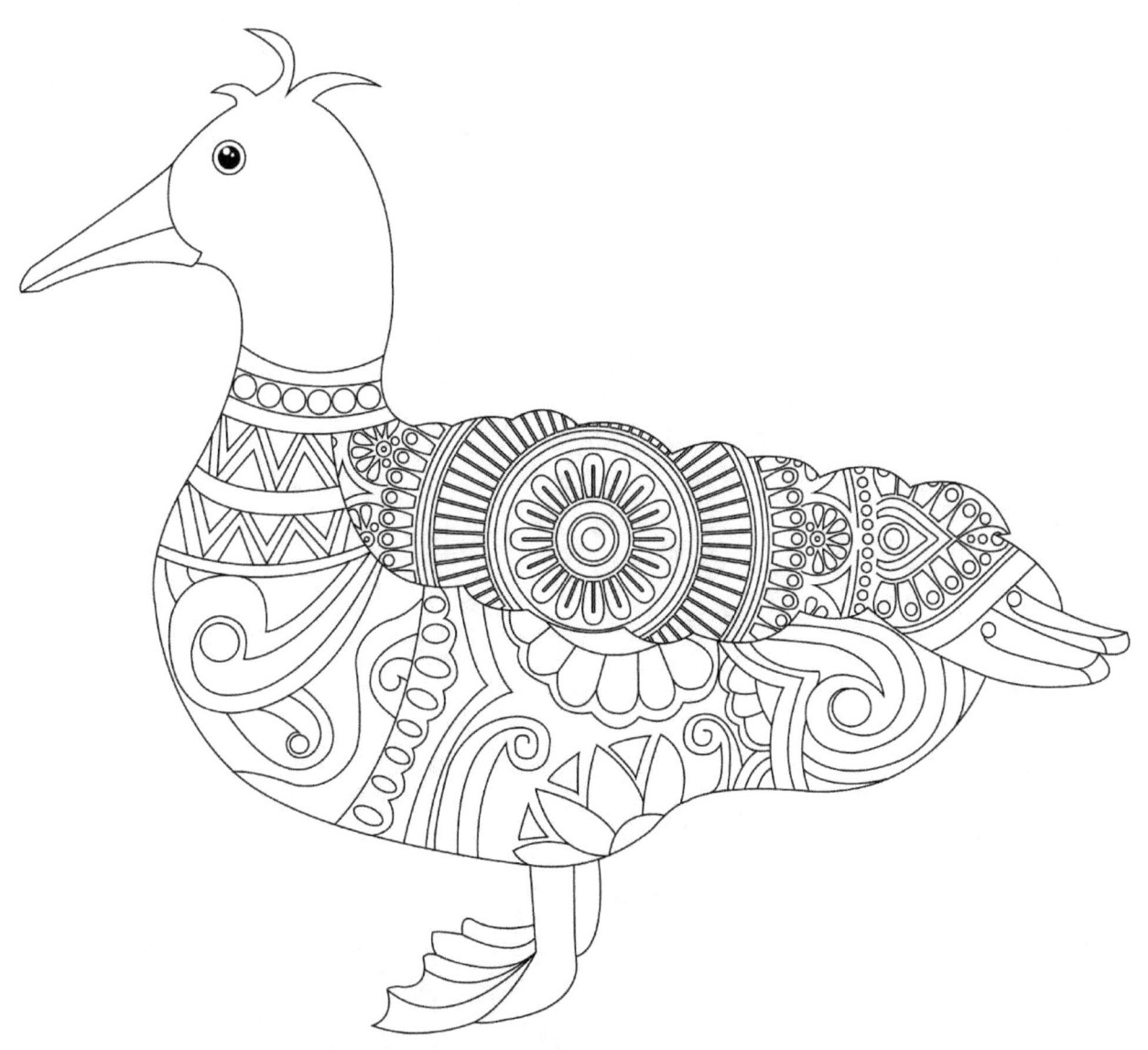

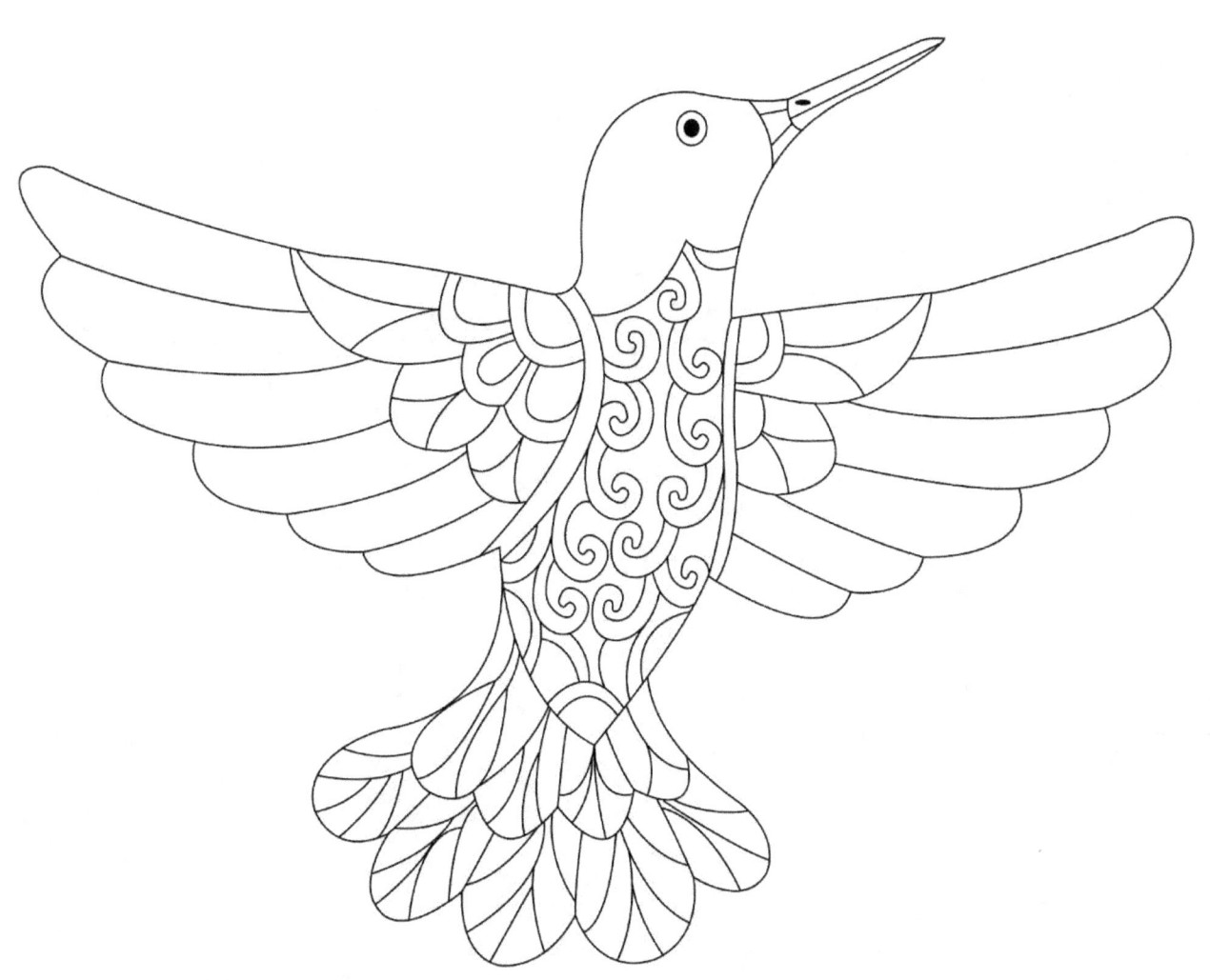

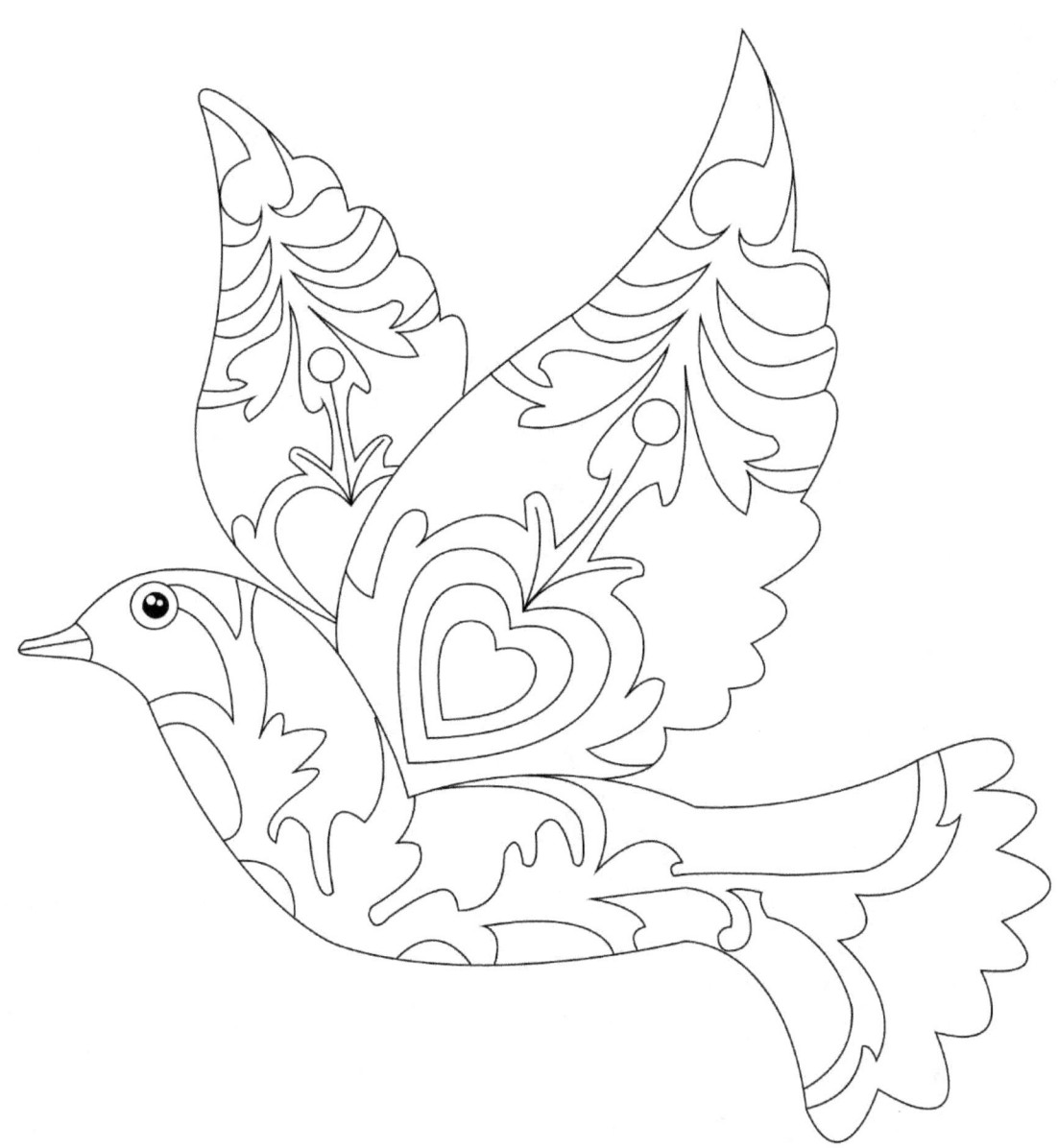

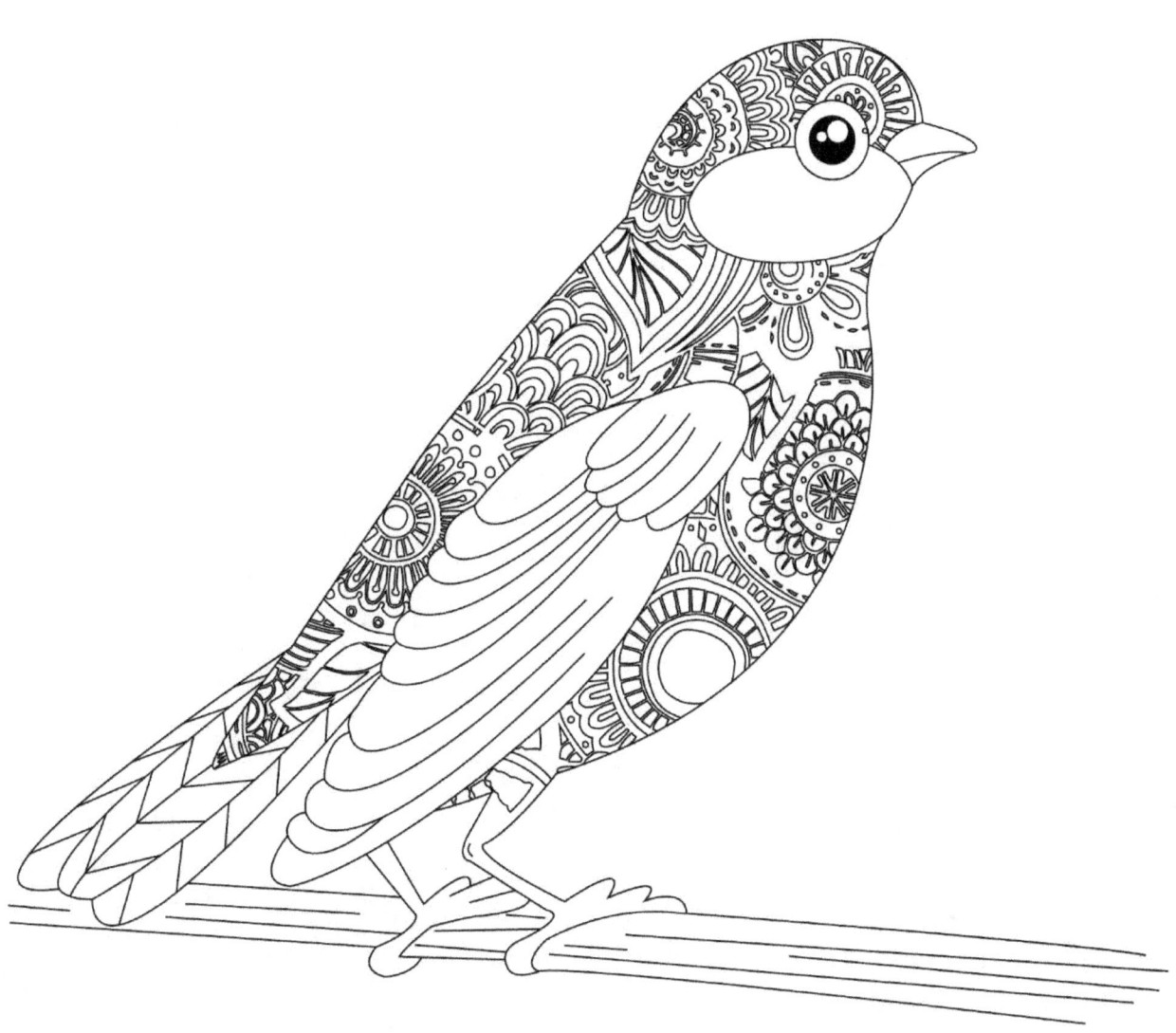

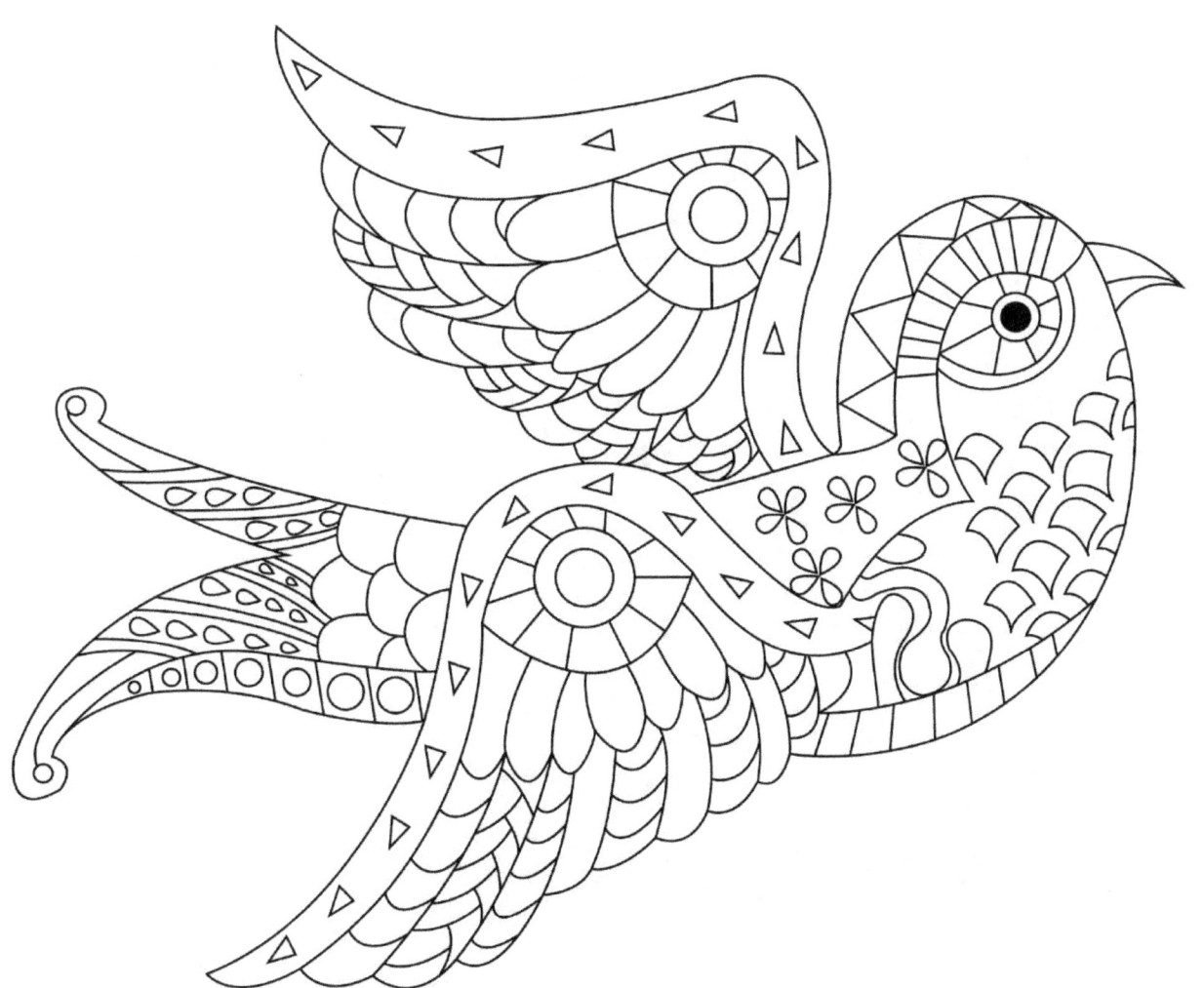

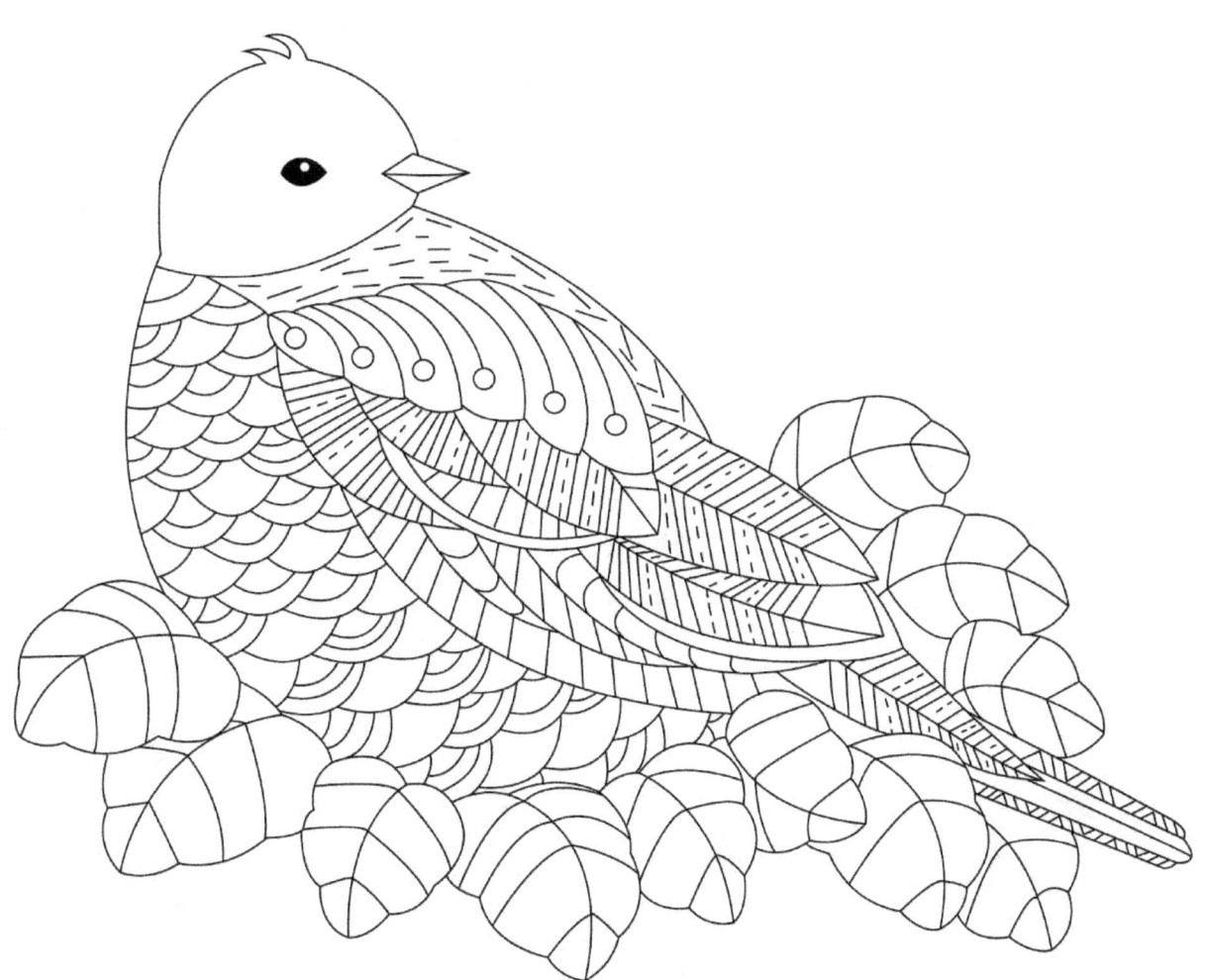

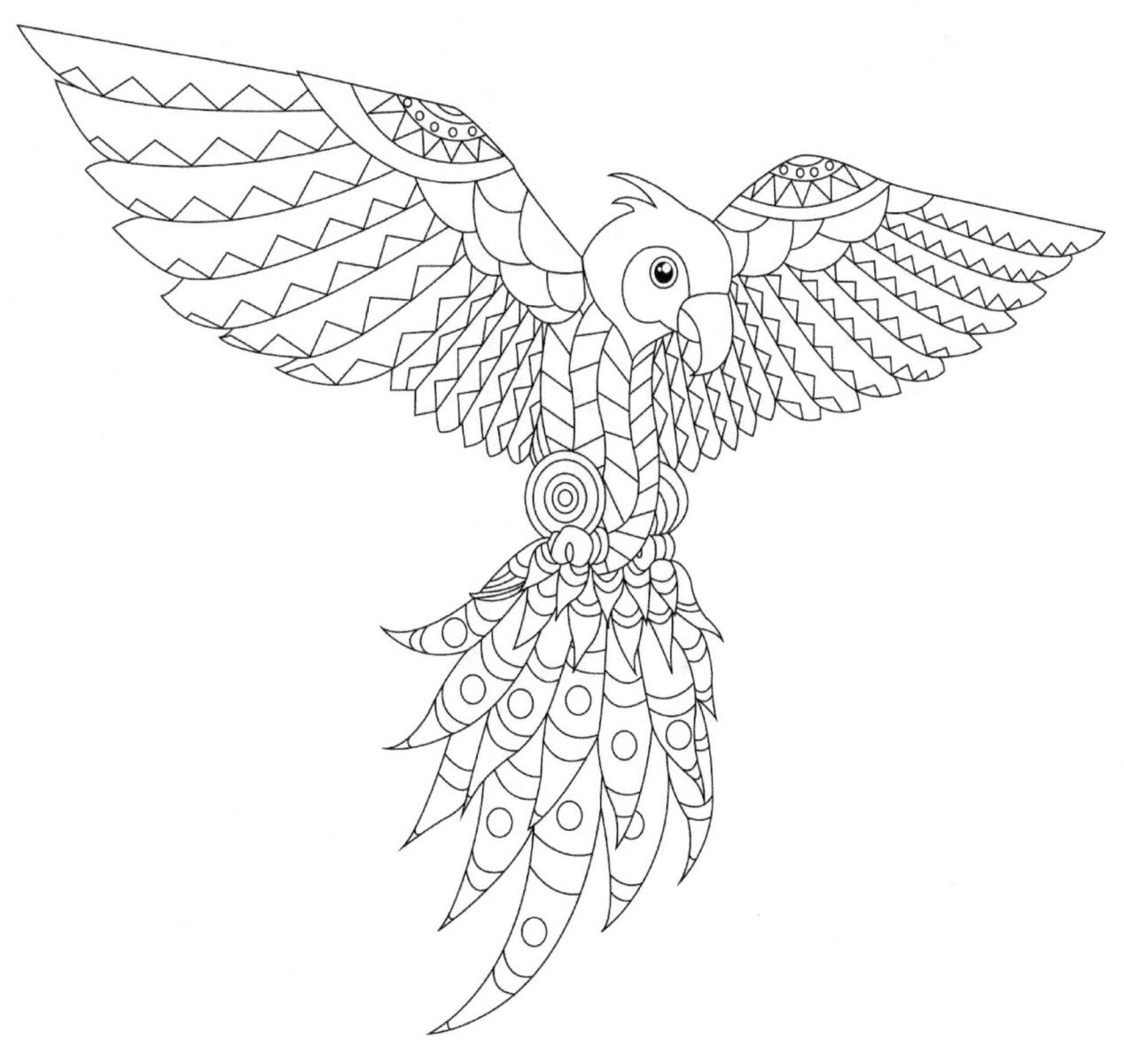

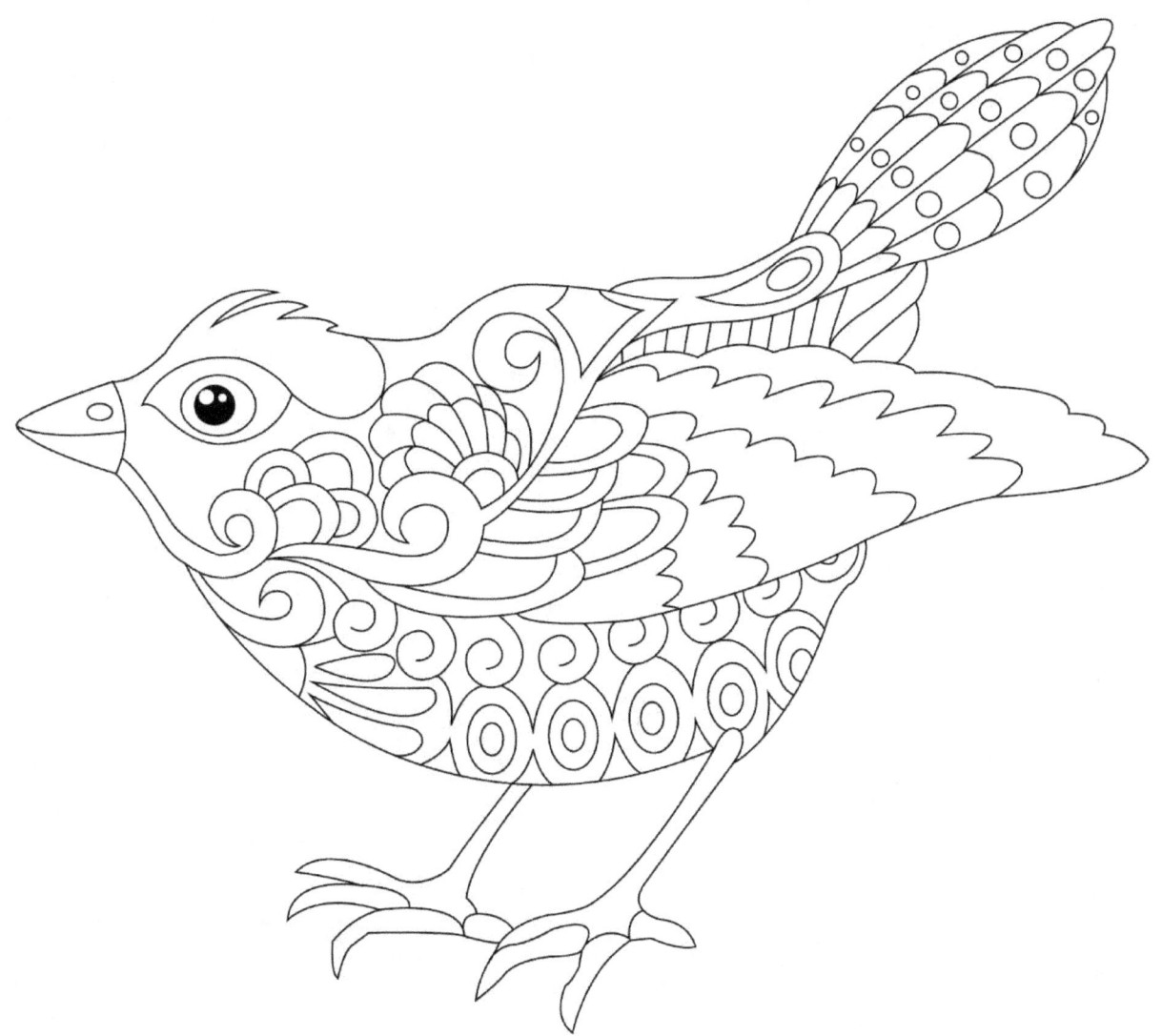

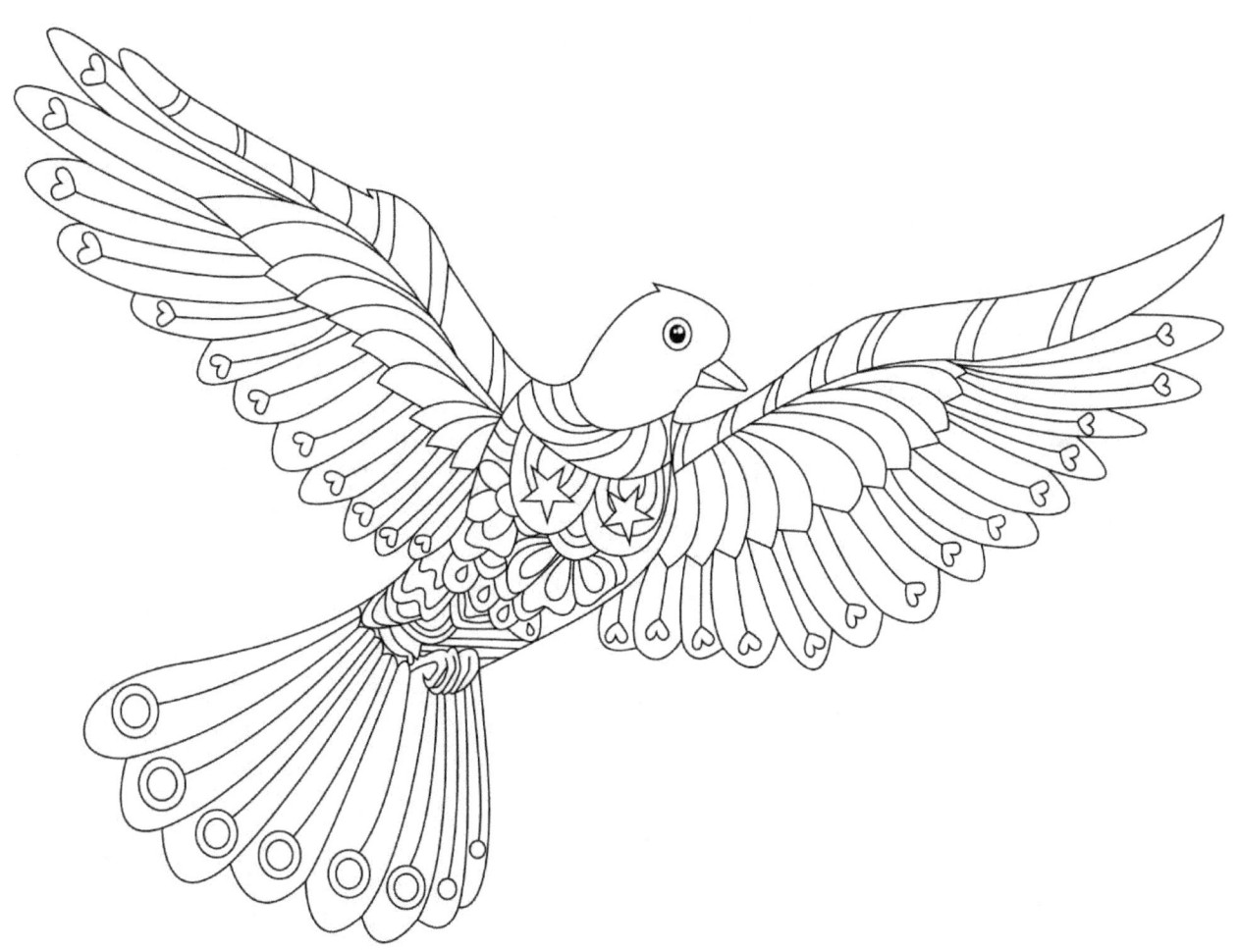

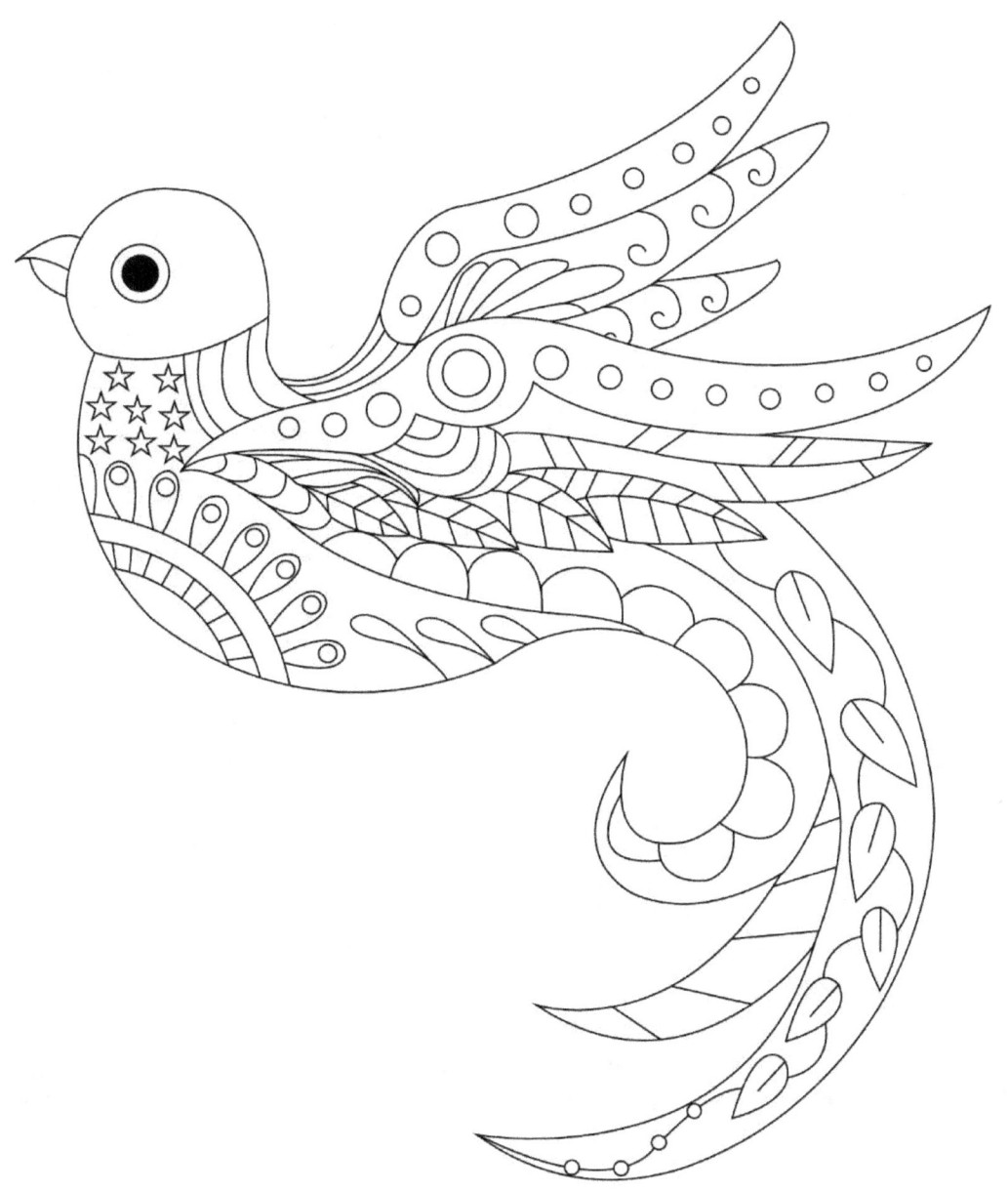

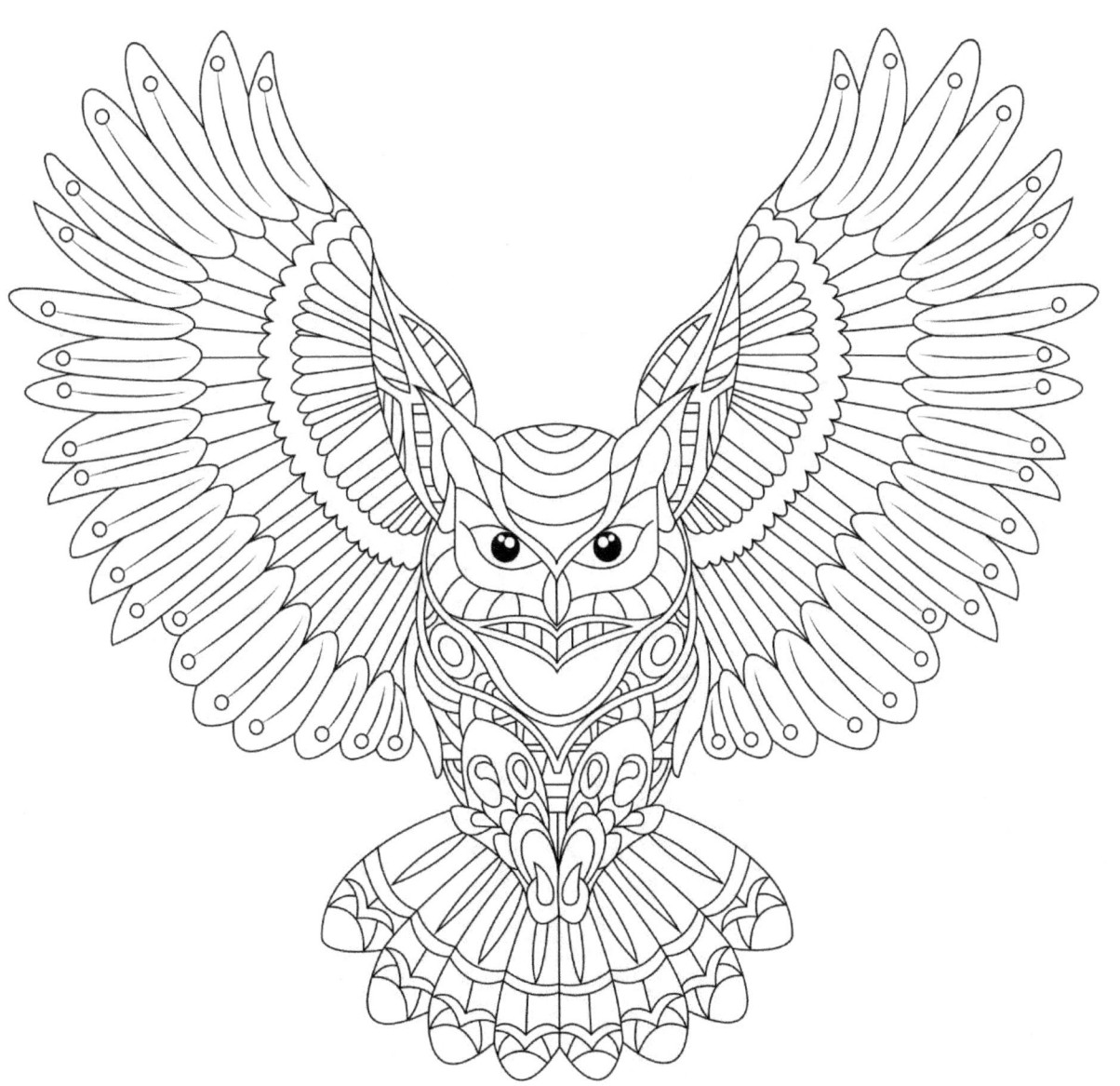

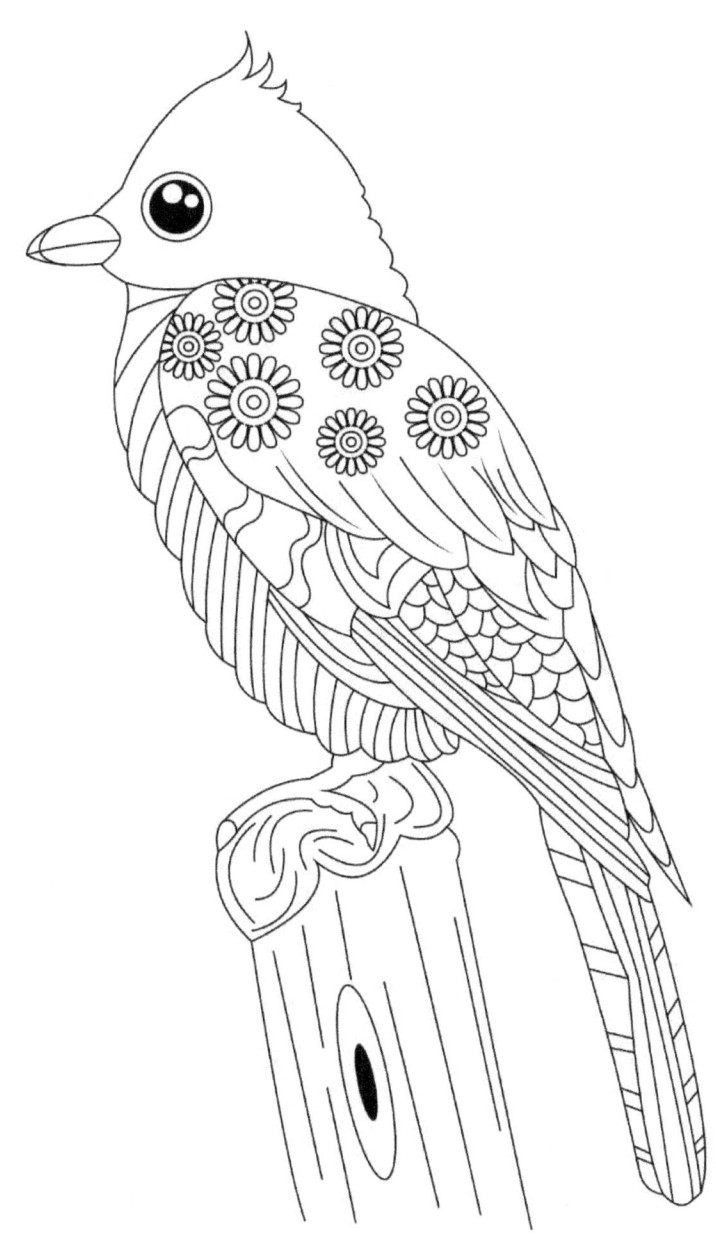

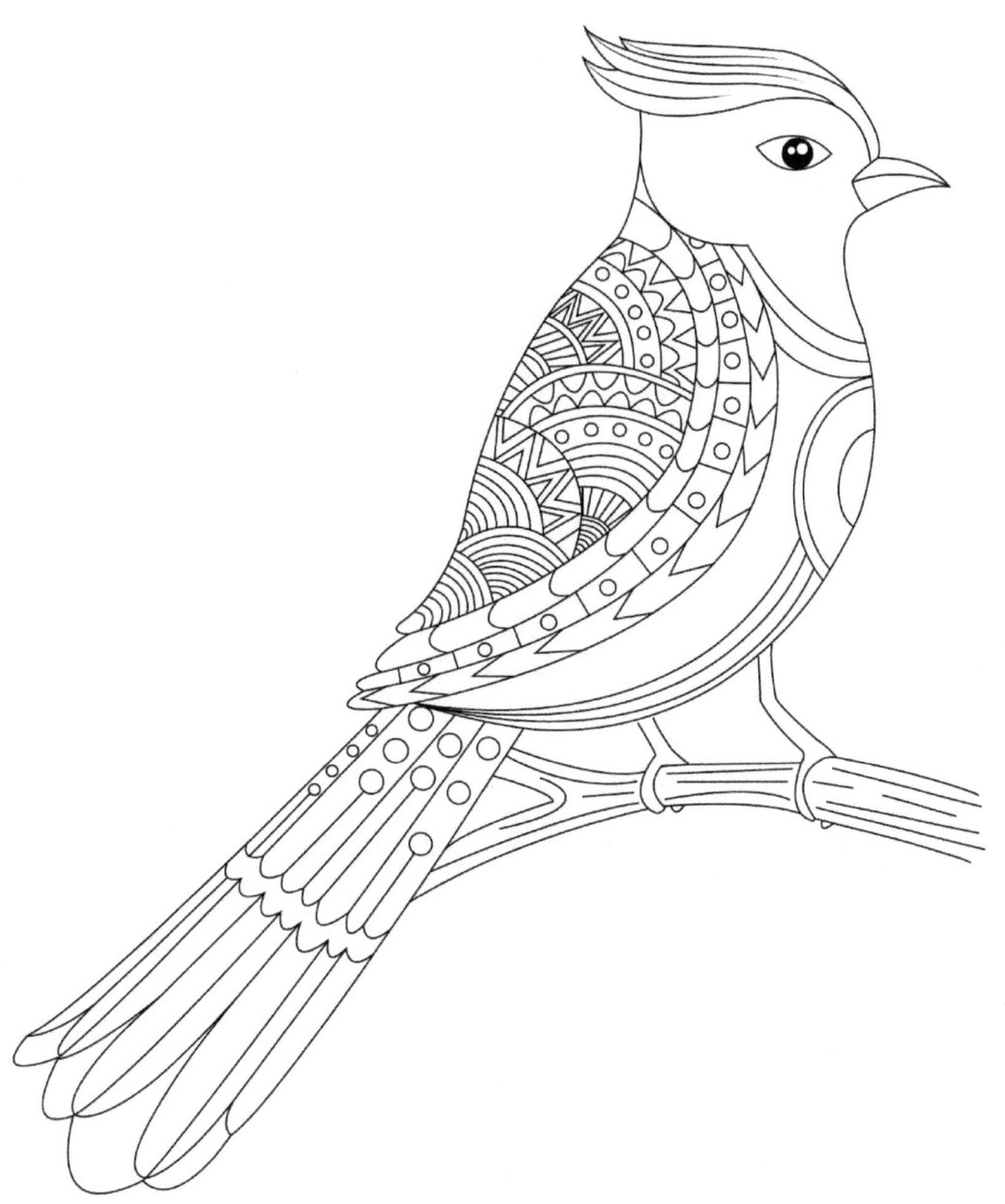

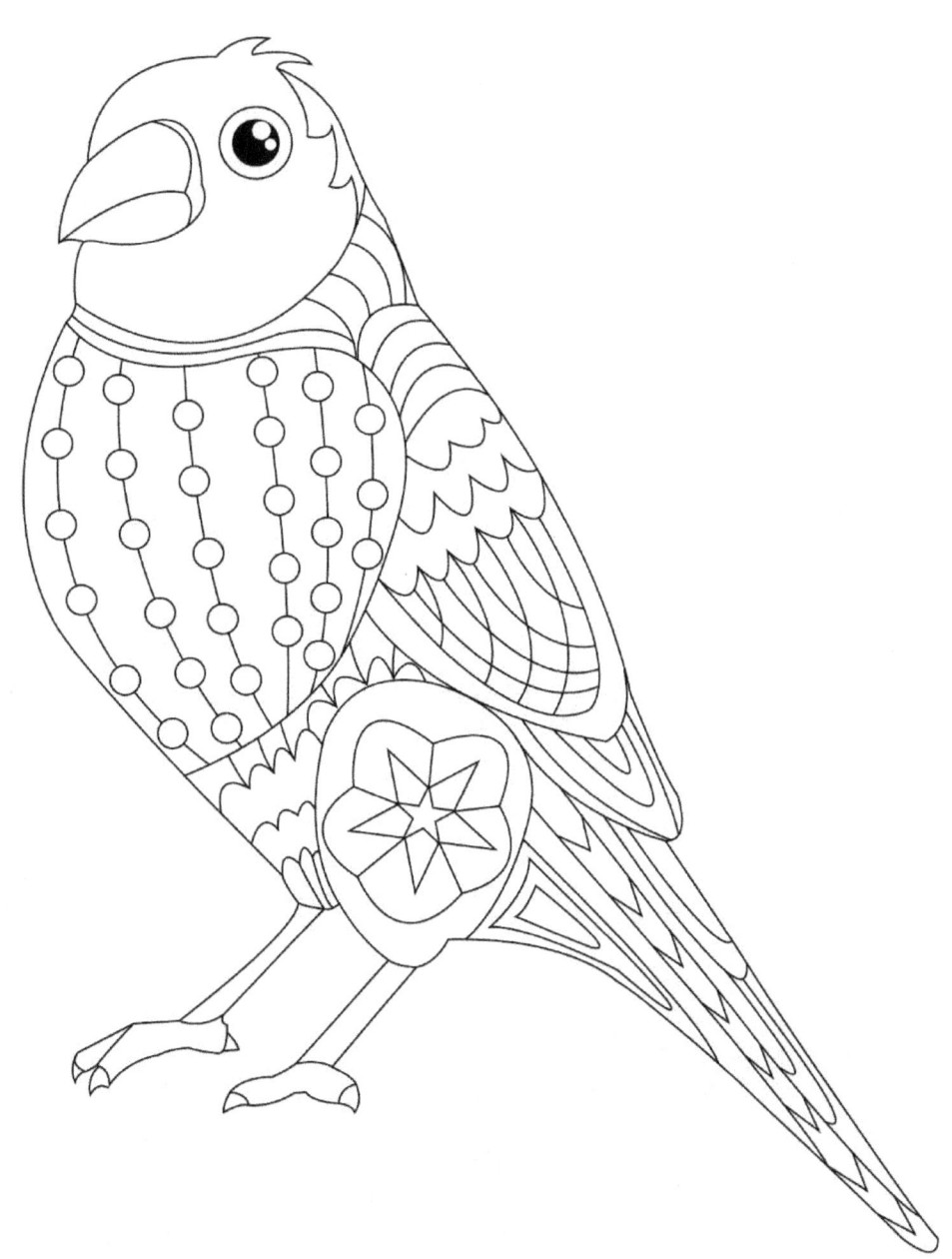

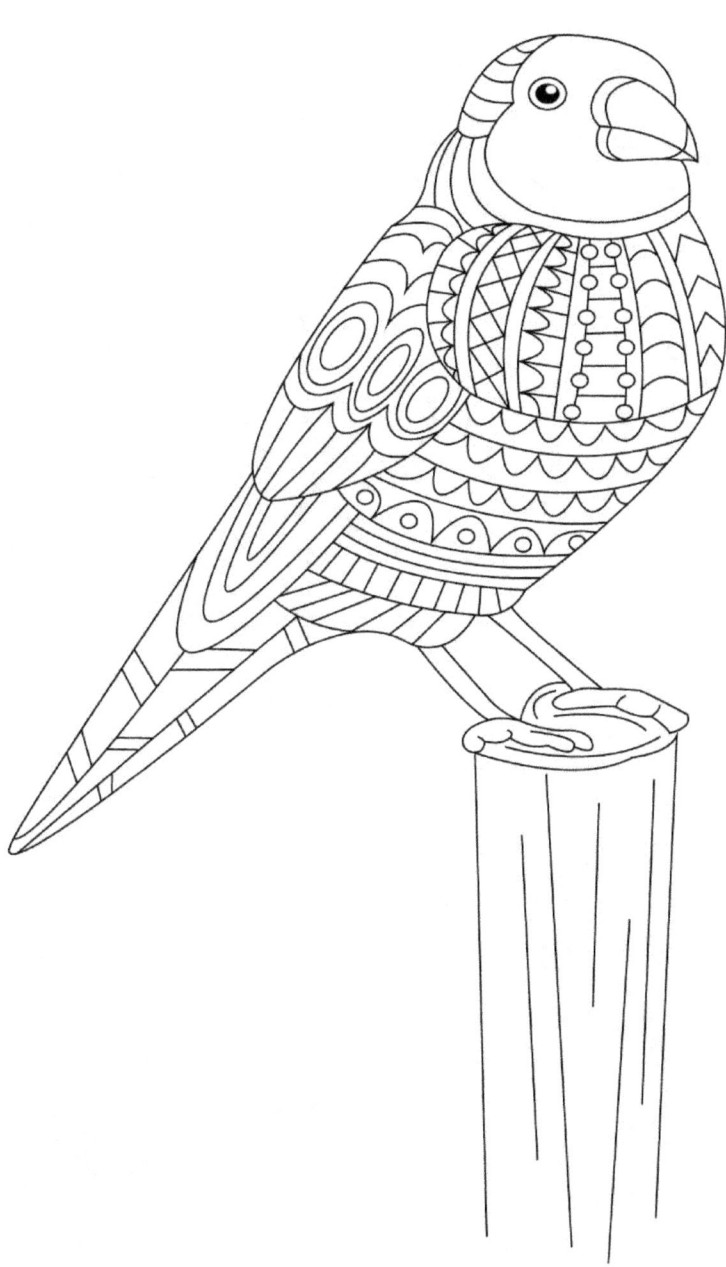

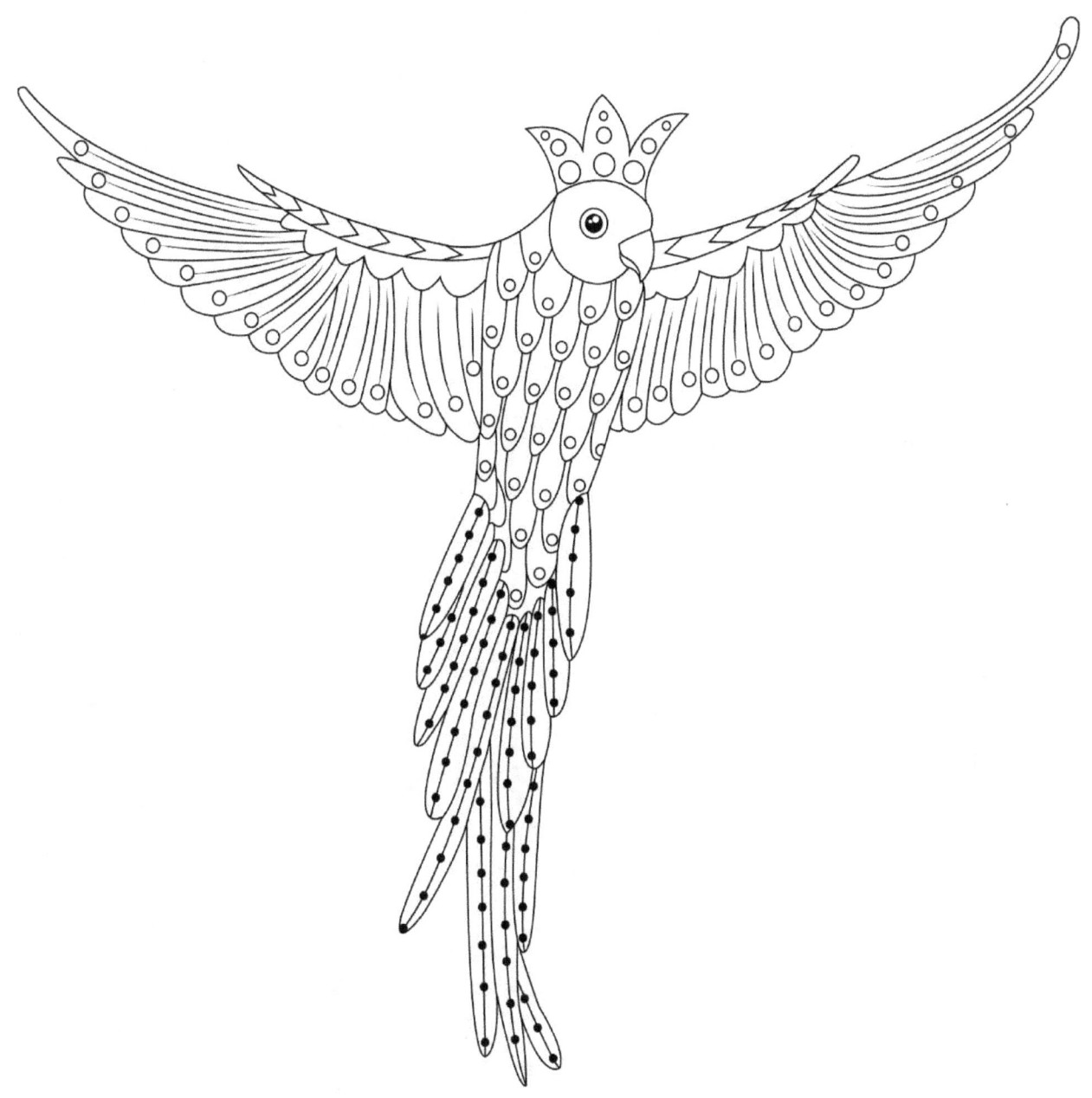

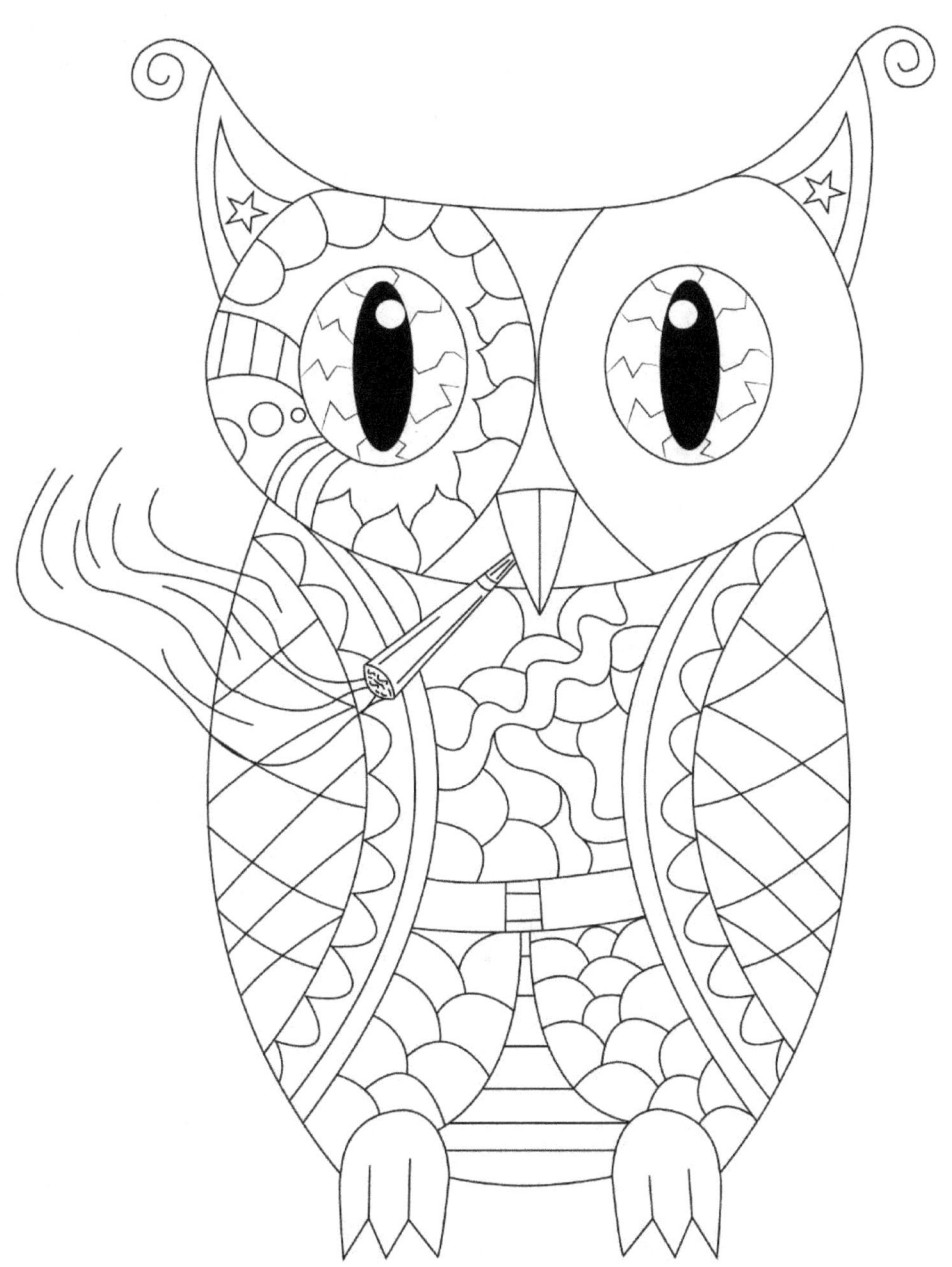

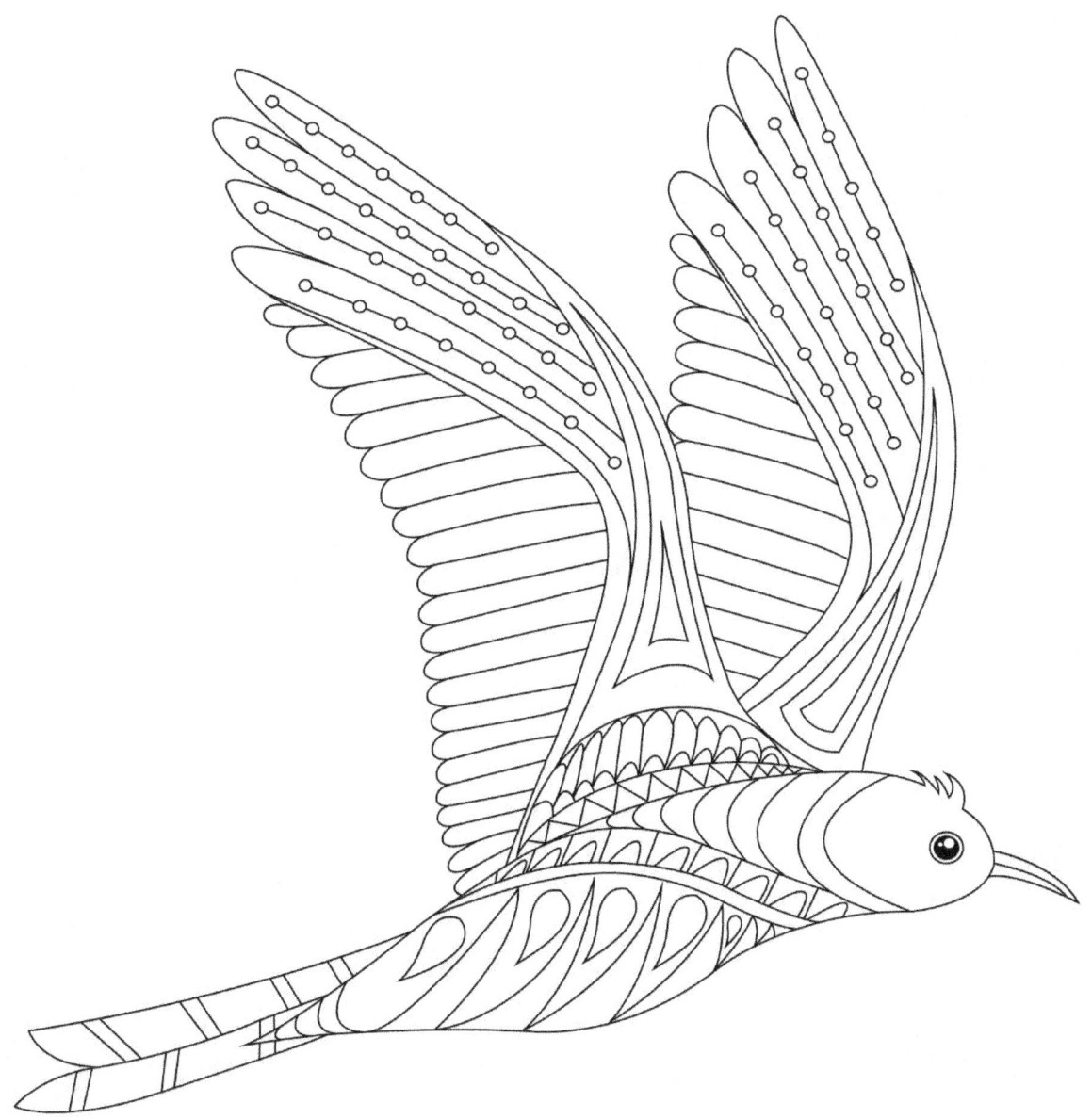

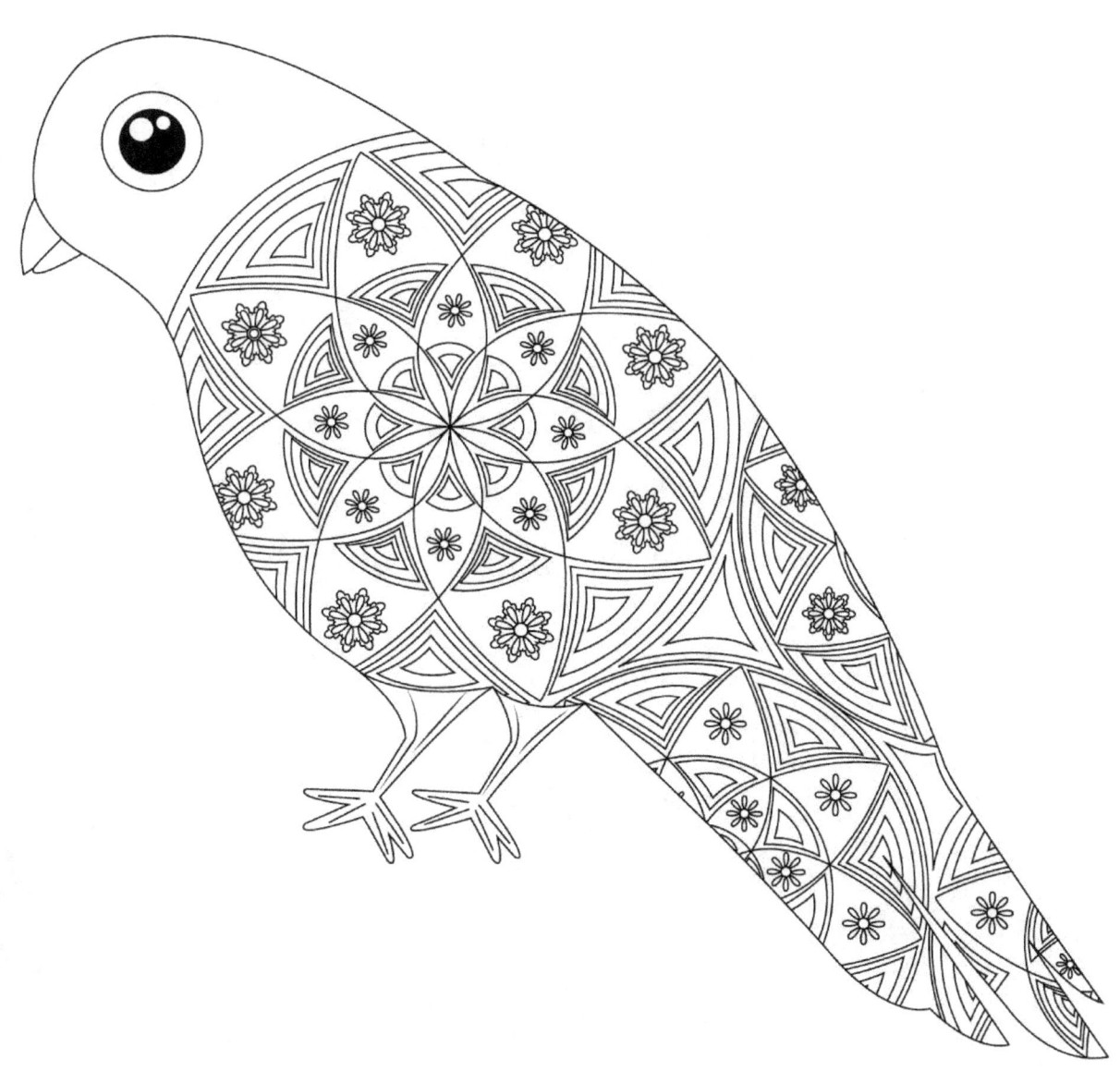

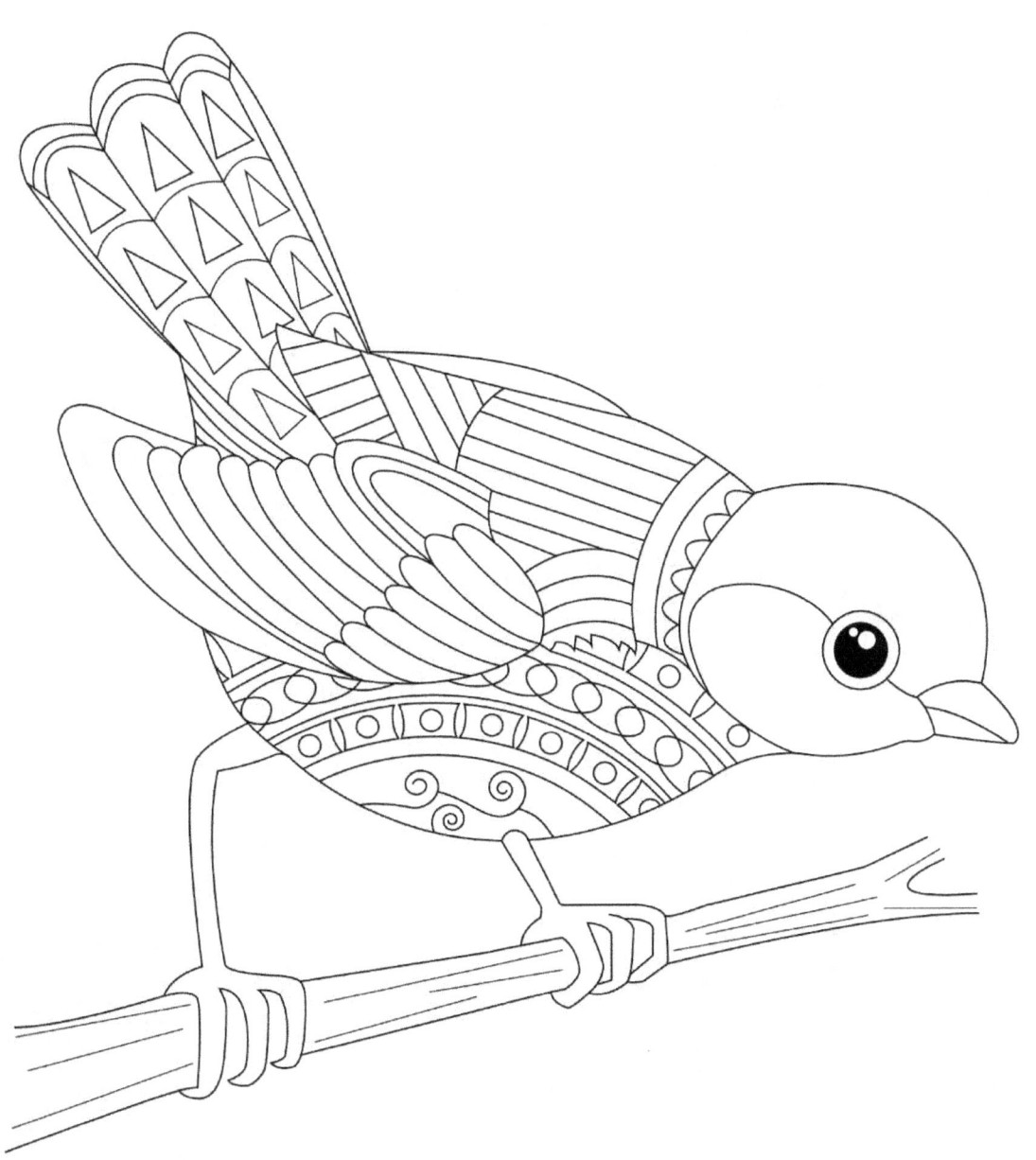

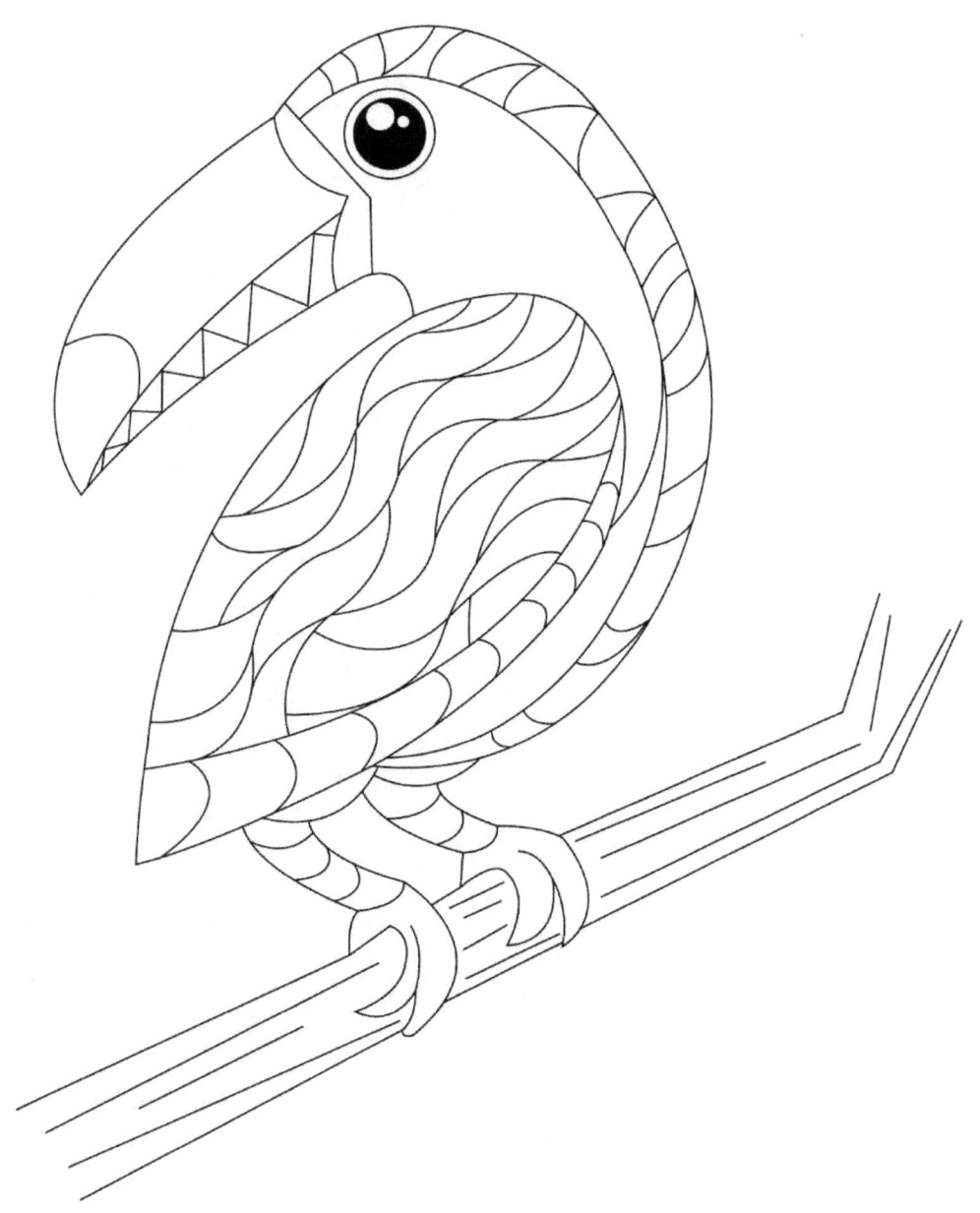

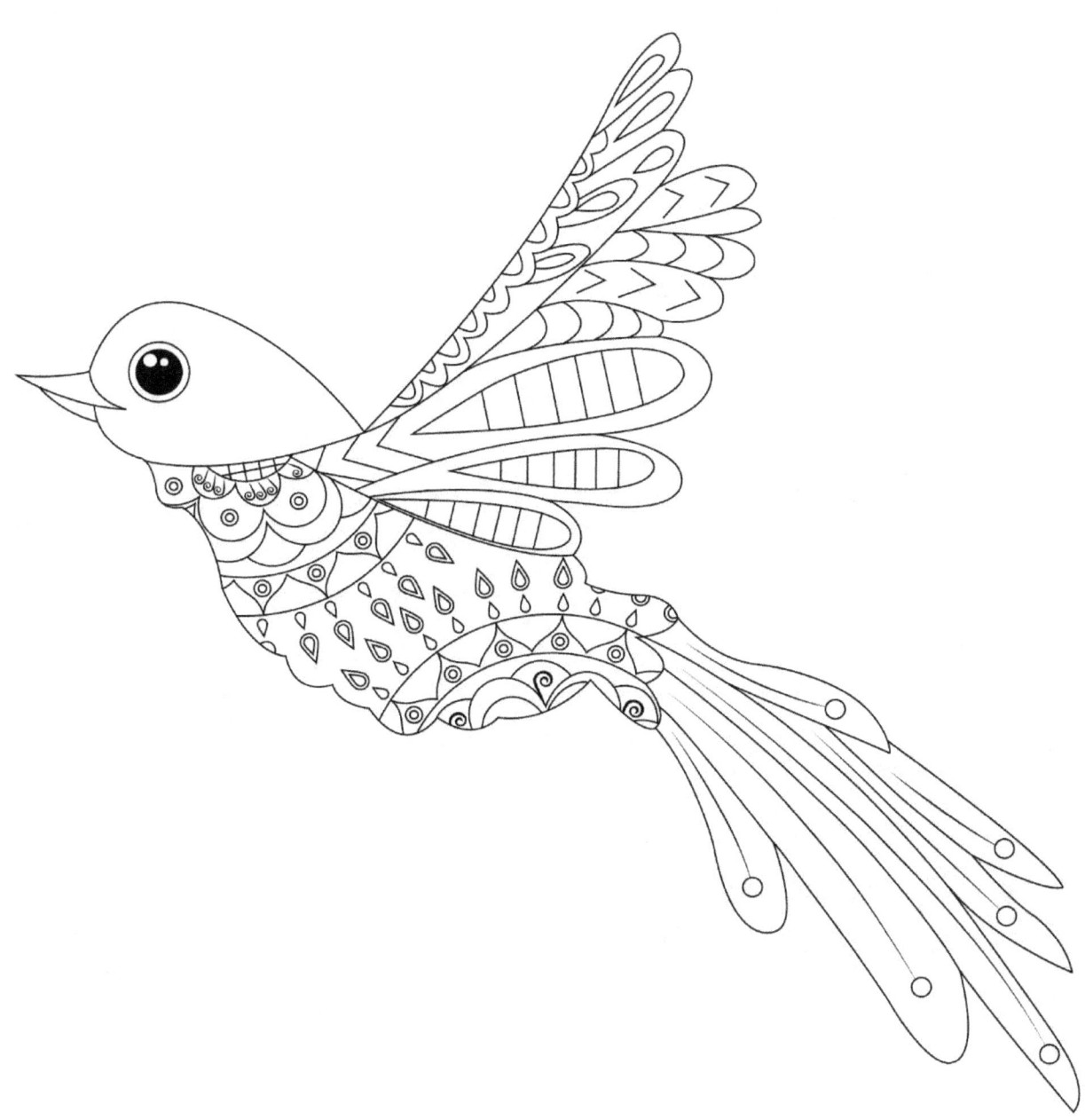

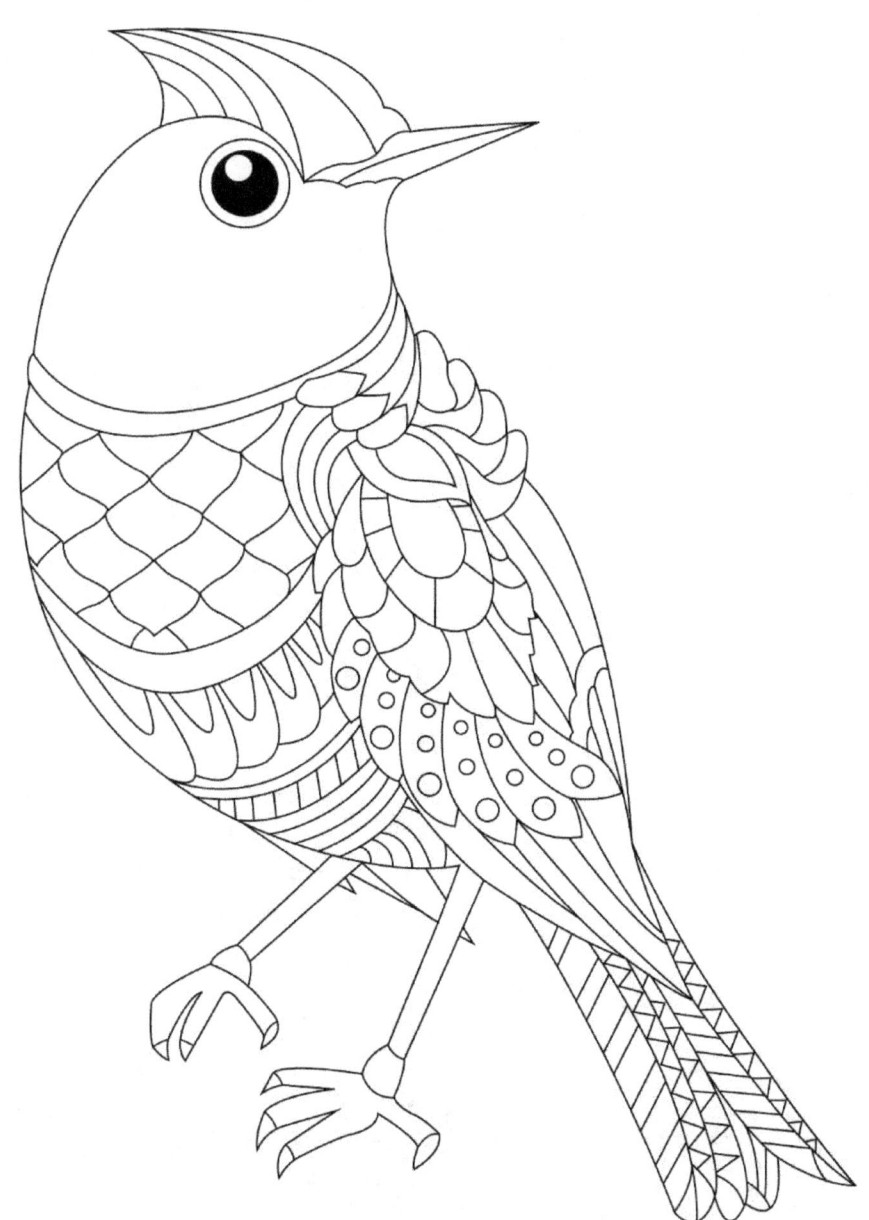

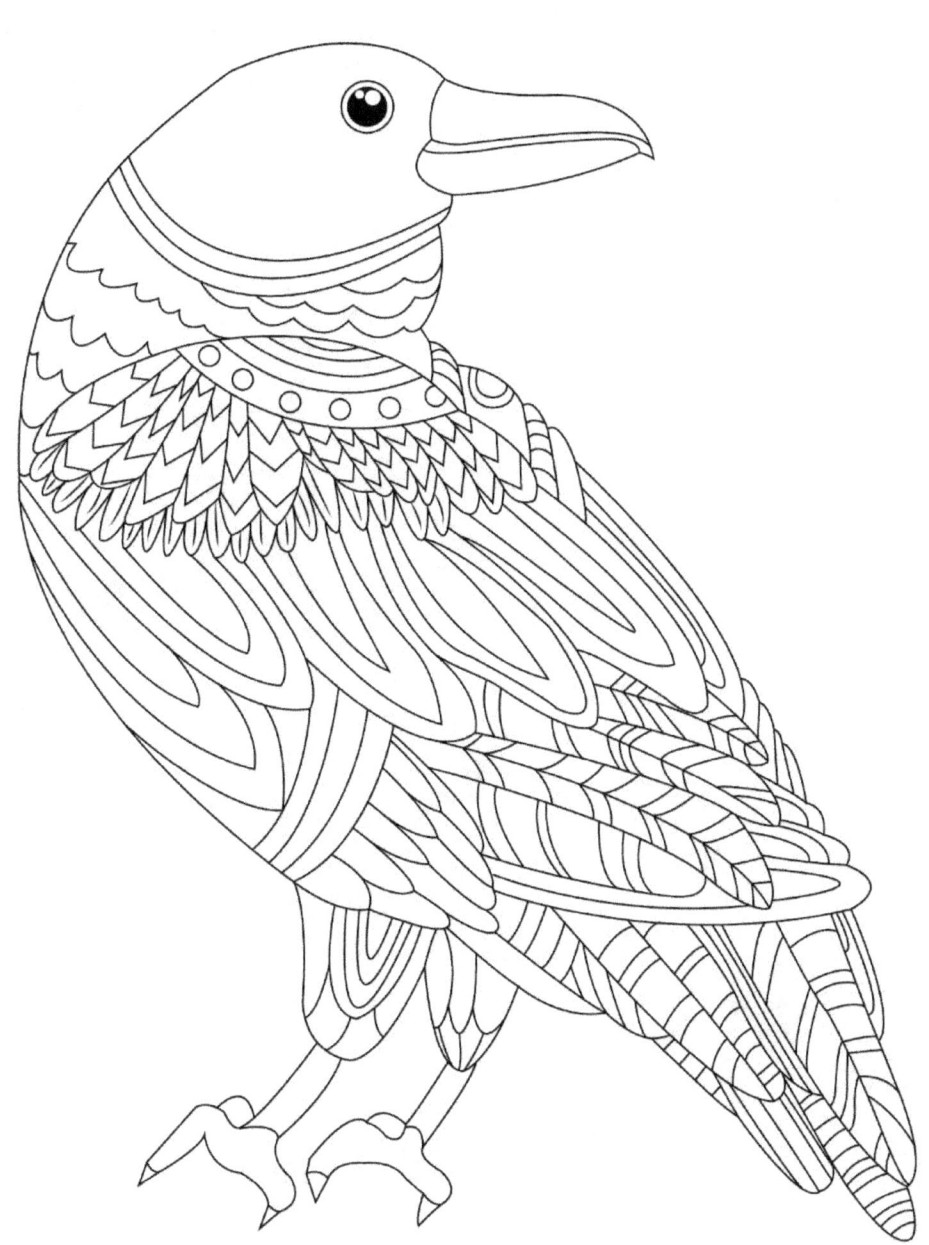

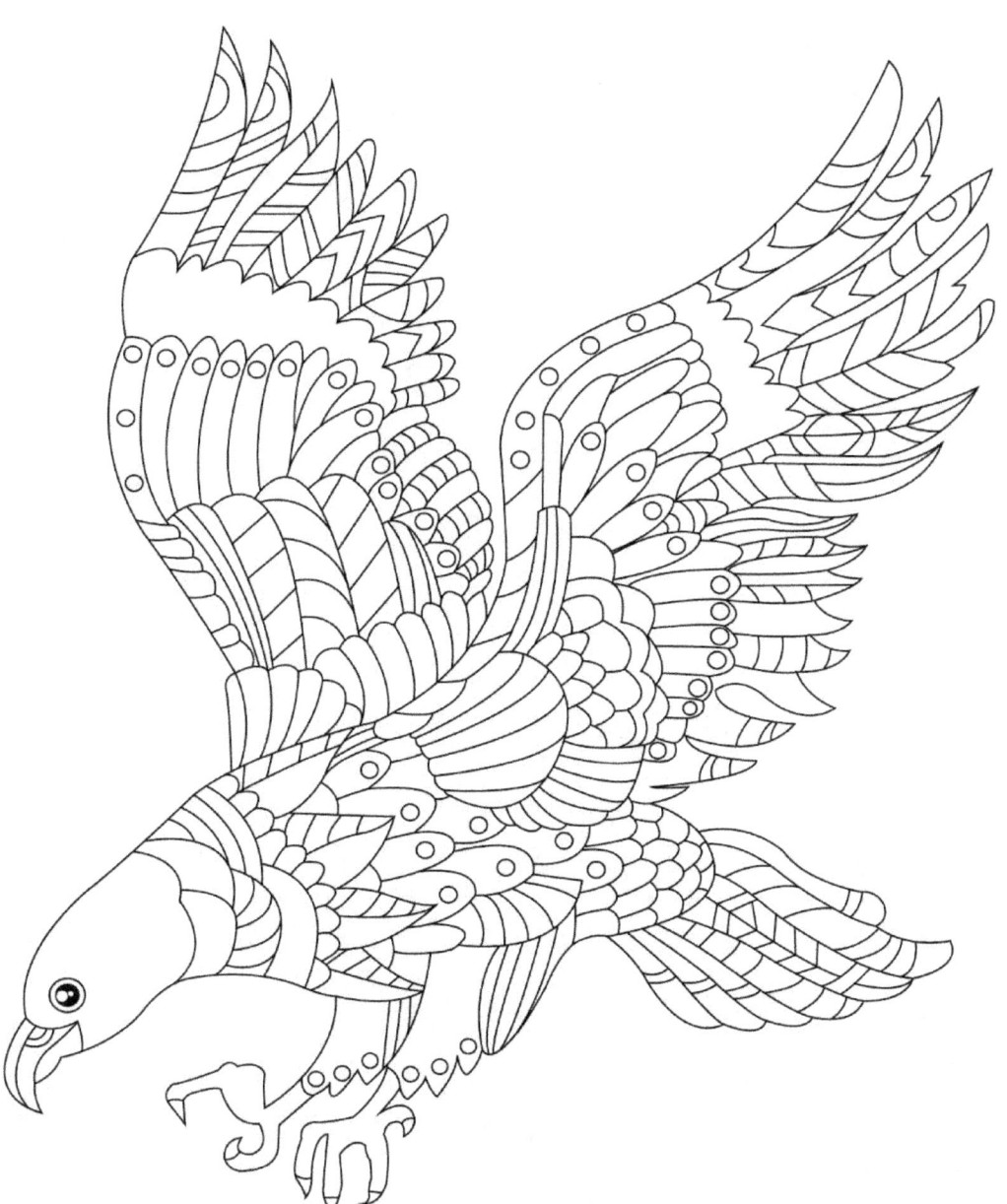

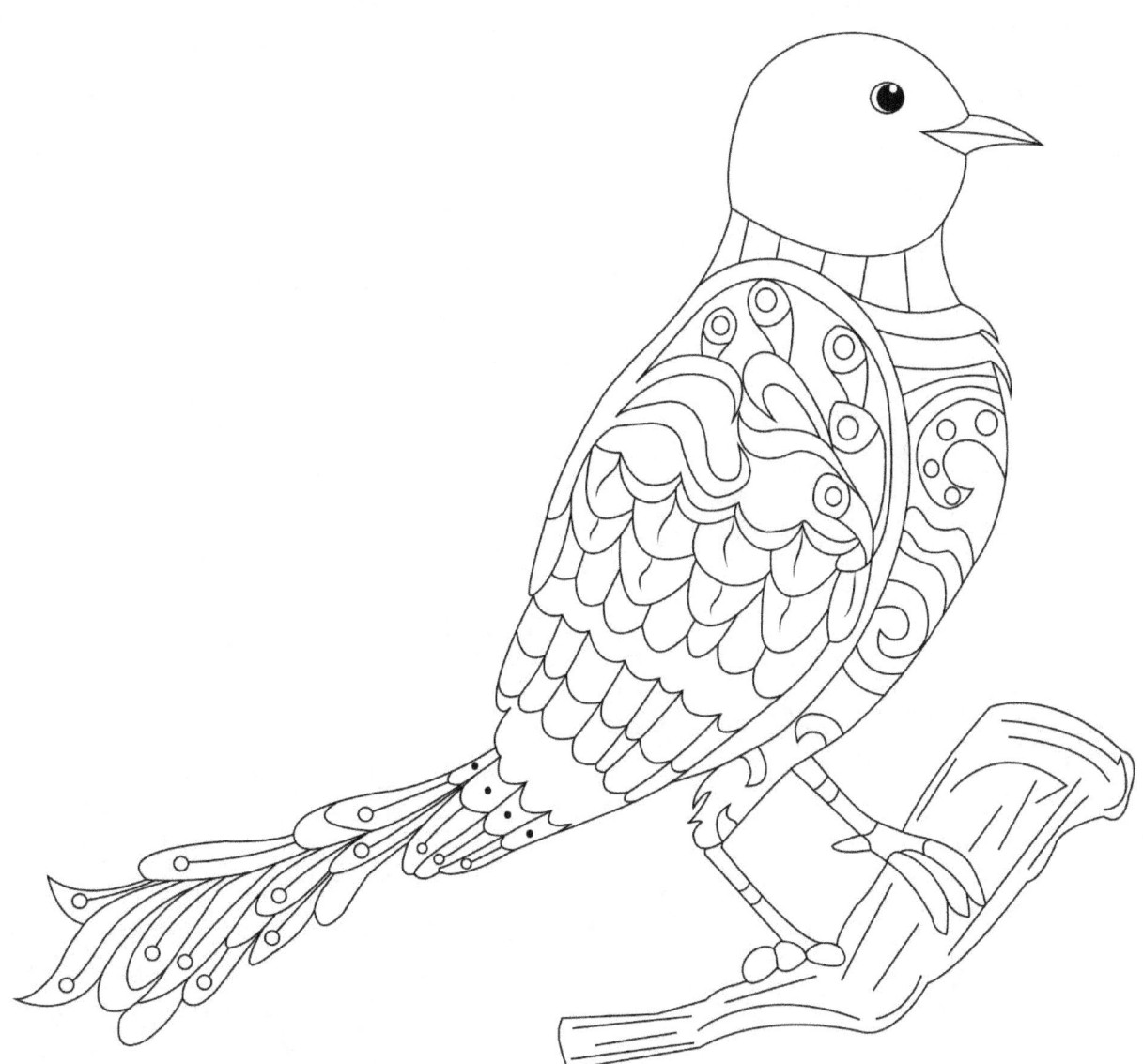

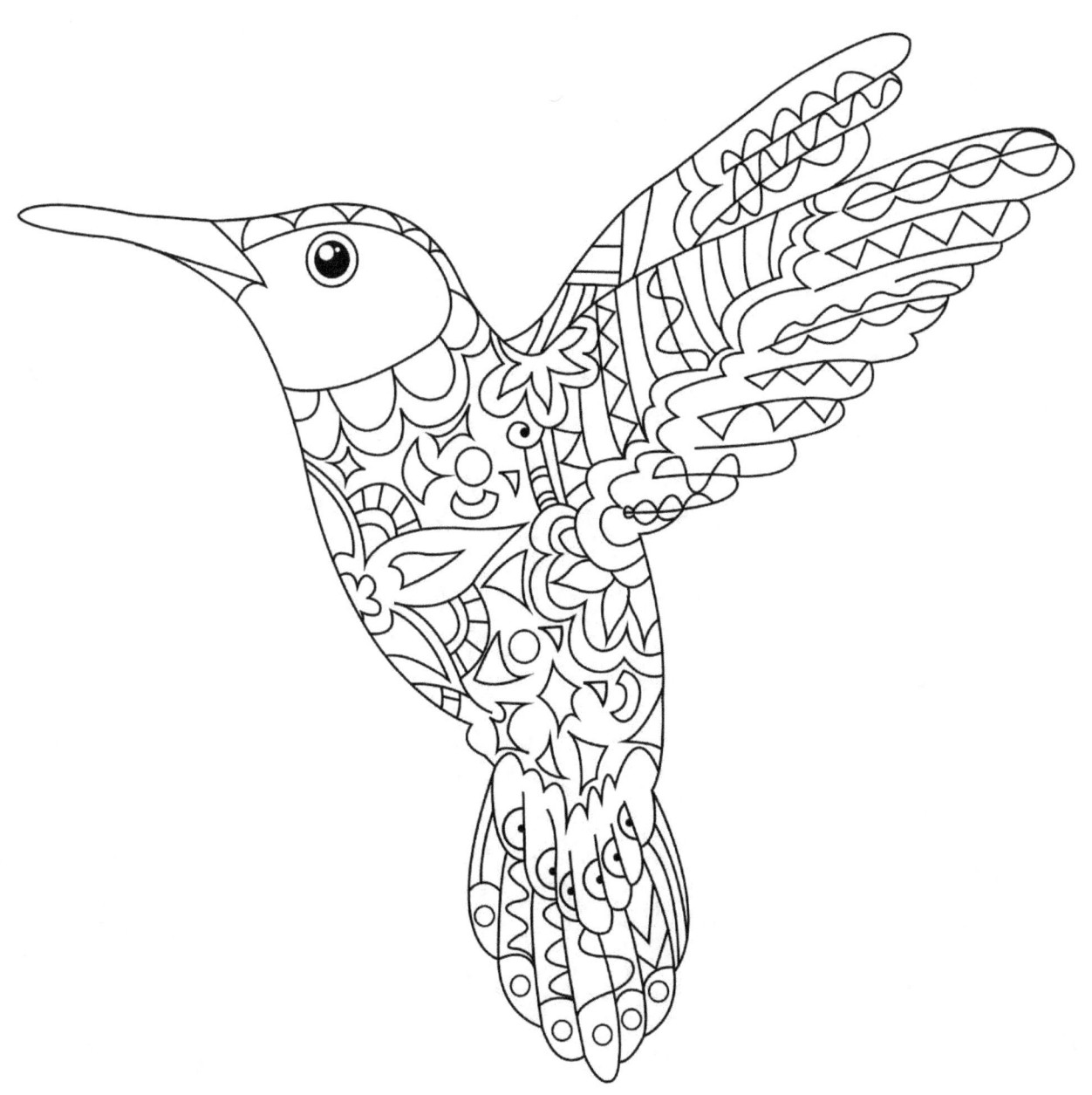

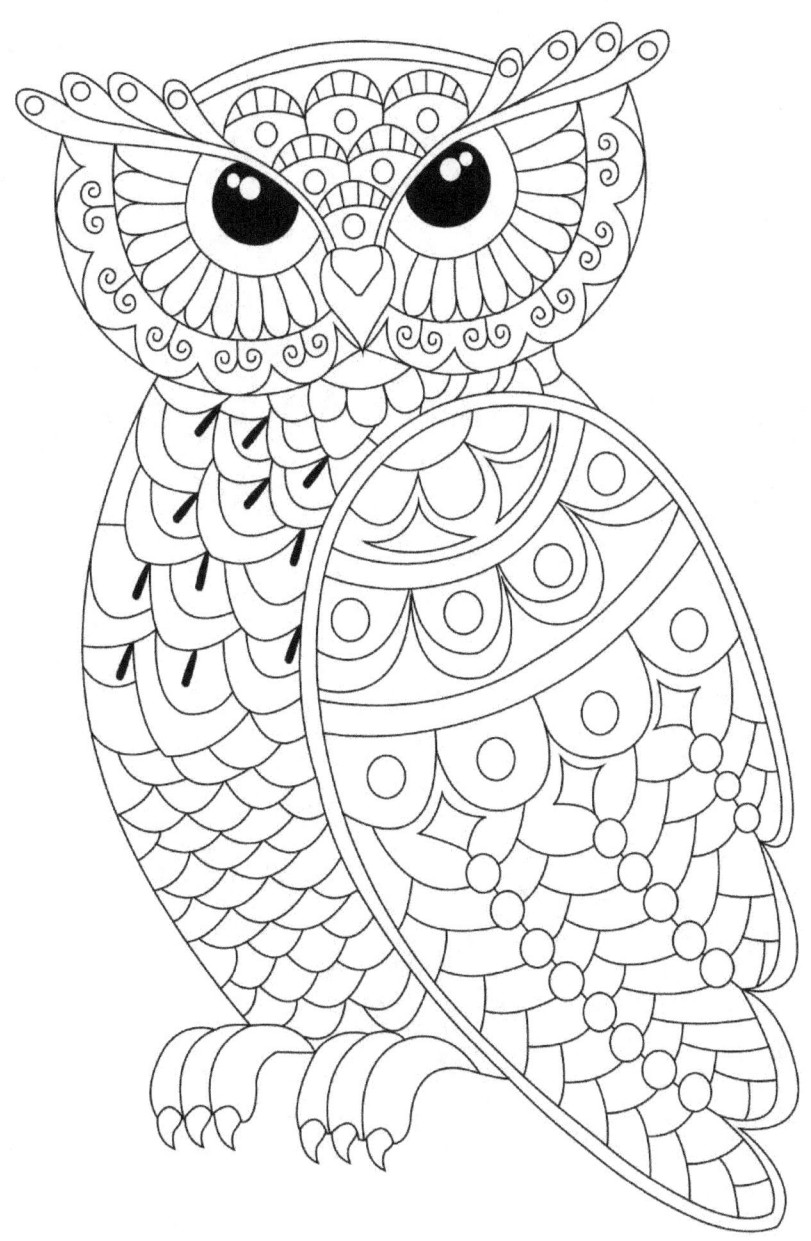

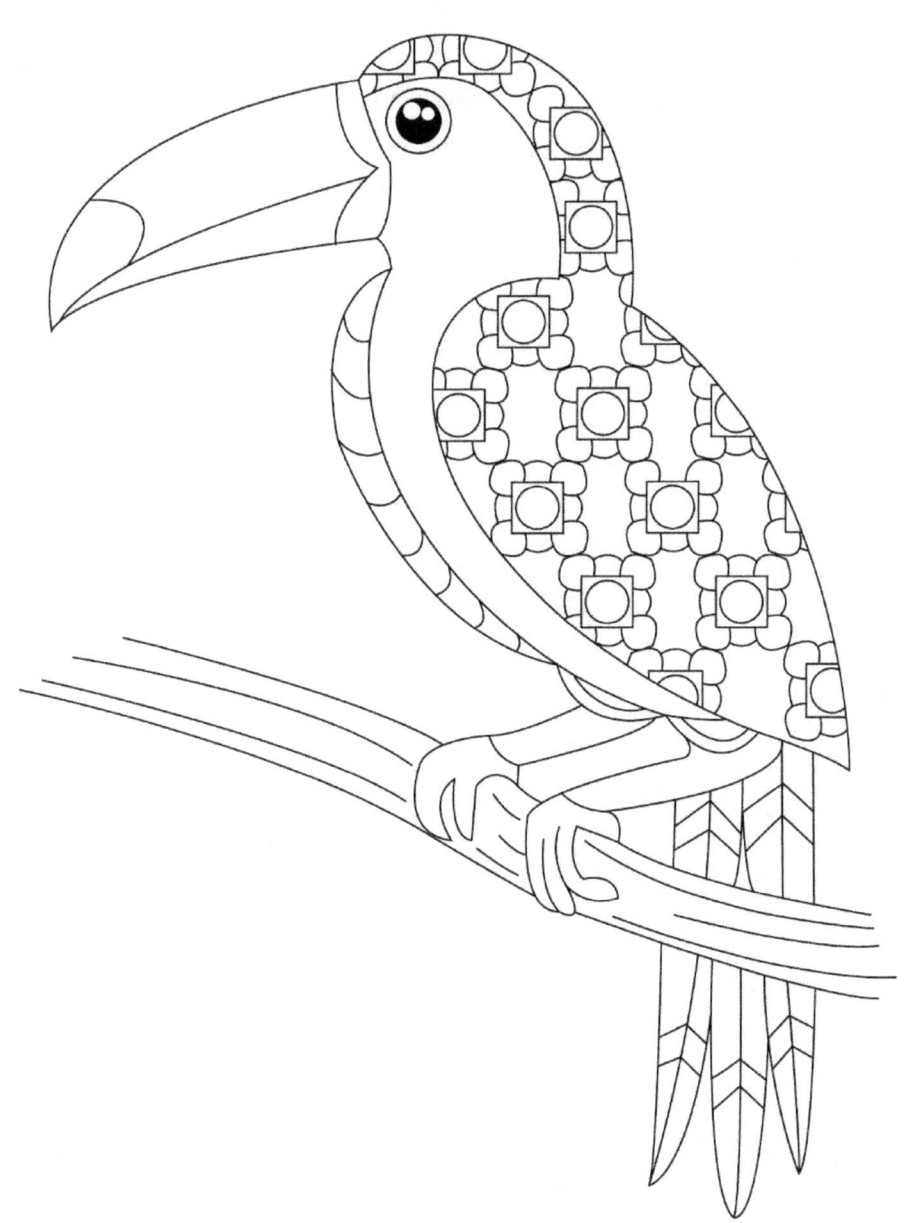

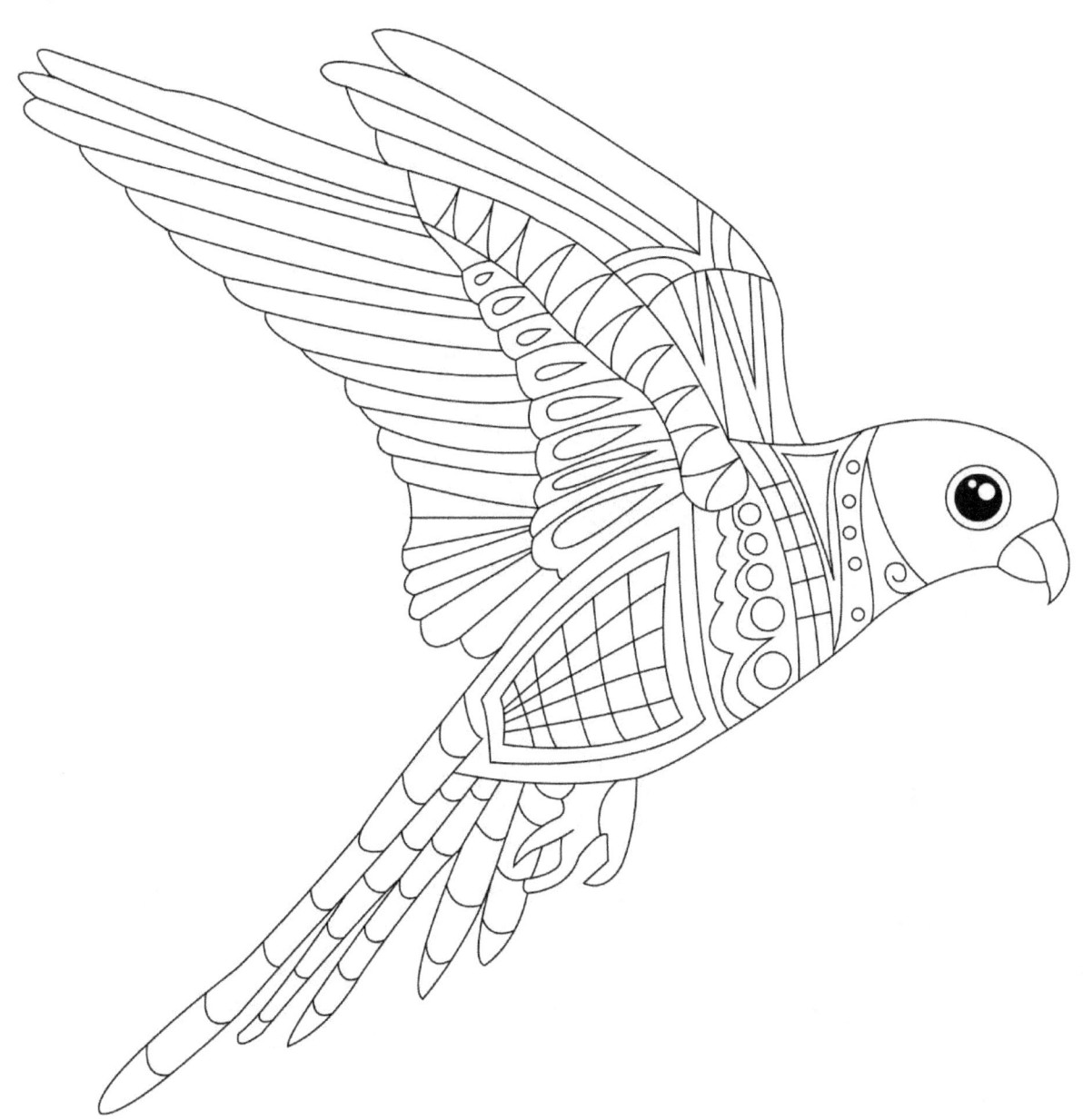

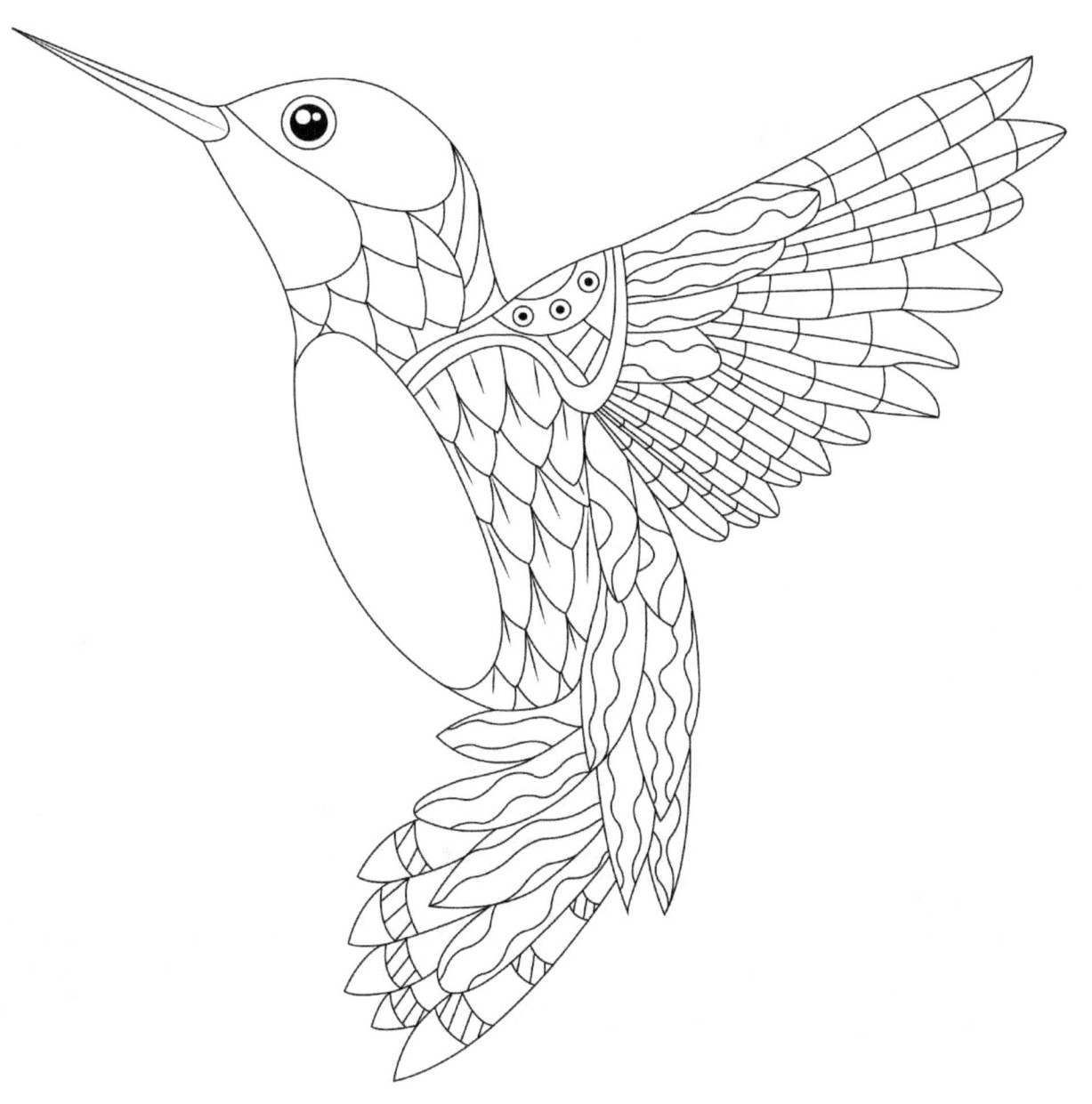